IMAGES
of America

EAST HAMPTON

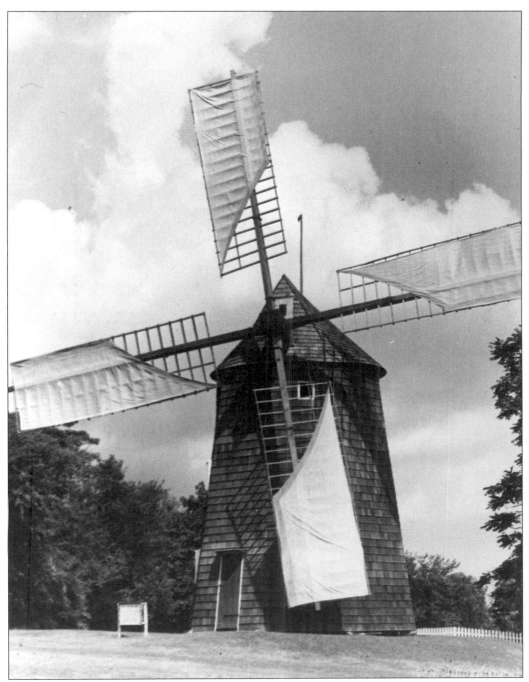

A village landmark on North Main Street and a popular subject for East Hampton's first wave of artists, the Hook Mill was built in 1806 from logs felled on Gardiner's Island and transported to East Hampton by boat and ox team. It was operated by Nathaniel Dominy VII, the grandson of the builder, until 1908. In 1922, the village acquired it, restoring it to working order in 1939. (East Hampton Library.)

IMAGES
of America

EAST
HAMPTON

John W. Rae
East Hampton Library

ARCADIA

First published in 2000.

Published by Arcadia Publishing,
an imprint of Tempus Publishing, Inc.
2 Cumberland Street
Charleston, SC 29401

Printed in Great Britain.

Library of Congress Catalog Card Number: 00-101922

For all general information contact Arcadia Publishing at:
Telephone 843-853-2070
Fax 843-853-0044
E-Mail sales@arcadiapublishing.com

For customer service and orders:
Toll-Free 1-888-313-2665

Visit us on the internet at http://www.arcadiaimages.com

ACKNOWLEDGMENTS

This book could not have been compiled without the assistance of a great many people. Our appreciation goes to all who generously contributed their assistance, information, and photographs.

We would like to thank: Ann Chapman, Diana Dayton, Dorothy T. King, and Tom Twomey of the East Hampton Library; Harvey Ginsberg for donating his postcard collection to the East Hampton Library; Clarence E. King Jr.; Karen Hensel and Jacqueline Rea of the East Hampton Historical Society; Joan Denny, Gail Parker, and Ann Roberts of the Ladies Village Improvement Society of East Hampton; Betsy Cunningham and Ruth Appelhof of the Guild Hall of East Hampton; Dr. Mildred DeRiggi of the Nassau County Museum Long Island Studies Institute at Hofstra University for access to the Mattie Edwards Hewitt collection; Gary and Rita Reiswig of the J. Harper Poor Cottage; Wittendale's Florist and Greenhouses; the Cavagnaro family; Carrie D'Andrea; Adela H. Hiller; and Alice H. Kelly.

While our initial intention was to capture all of East Hampton, a wealth of interesting photographs and limited space reduced our focus to East Hampton Village and Gardiner's Island. Wainscott, The Springs, Northwest Woods, and points in between are rich in their own story and deserve further, separate investigation.

CONTENTS

FOREWORD

This delightful book makes a significant contribution to our understanding and appreciation of East Hampton. The 215 photographs, many of which have never been published before, provide a rare glimpse of the town over the last 150 years.

Due in large part to the efforts of John Rae and his son Chip Rae, this book opens many windows into East Hampton's past. While looking through these portals, we can see how this community has changed; we can also see how much of our buildings, homes, and monuments have been preserved.

East Hampton is known for its preservation as a small town. It is also known for its unique historical archive contained in the Long Island Collection at the East Hampton Library. The archive contains thousands of wills, family letters, maps, whaling logs, books, photographs, and other papers donated by residents of the community to help document our town's 350-year history.

Diana Dayton, the librarian of the Long Island Collection, and Dorothy T. King, research librarian, have worked with the Raes to provide photographs and write and verify captions to produce this lovely book. The East Hampton Library will use its portion of the proceeds from this book to help enhance and expand its archival collection of local history.

The more we understand our roots and the roots of our community, the more we understand the world in which we live. By understanding more of East Hampton's history, you will be helping to preserve its roots and, at the same time, its future.

—Tom Twomey, president of the East Hampton Library

INTRODUCTION

Long Island stretches a surprising 120 miles east into the Atlantic Ocean from the island of Manhattan. On its south fork, 18 miles shy of land's end at Montauk Point, the village and surrounding town of East Hampton have bathed in glorious sunlight for 350 years. At first glance, the community appears to have more in common with the 19th century than the modern metropolis to the west. Its settlement, architecture, early trade, orientation to the sea, and the habits and customs of its original citizens were pure England, by way of New England.

Founded in 1648, East Hampton is relatively old and still small as American towns go. Until recently, it has remained substantially unchanged. Although development pressures now nibble at its very core, change has been kept at bay by a vigilant coalition of local institutions. Their collective ability to preserve a quiet, dignified village is increasingly challenged by a galloping economy and the gradual suburbanization of a long popular resort.

For several generations, the community has taken pride in thinking of itself as "America's Most Beautiful Village." Although the origins of the phrase are more legend than fact, the idea persists in the minds of those who guard its heritage. On its recent 350th anniversary, marked by 12 months of celebration, the population of East Hampton Village and Town stood at 18,500 people. Fifty years earlier, it was 8,000. The reality that its vast open spaces could be fully developed in the next generation is just now galvanizing public and private attention.

Set against this background, these images trace the evolution of East Hampton from a bucolic Eden to the international summer playground it has recently become. Along the way, several seminal events were critical in shaping its development.

The arrival of the first English colonists in the mid-17th century was relatively peaceful. The native Montauk Indians taught the English how to fish and farm, and the two formed a coalition to fend off the more aggressive Pequot and Niantic tribes from Connecticut. The original settlers divided the land around Village Green, laying out home lots off a broad Main Street and building saltbox-shaped homes. Their houses nearly always faced south, regardless of their orientation to the street, so as to catch the warmth and light of the sun. By 1660, however, the Native Americans had sold nearly all their land, paving the way for all sorts of future development.

The second invasion came late in the 19th century with much controversy. In 1894, the railroad terminated in Bridgehampton, with a spur to the sleepy port of Sag Harbor. Cut off from transportation to New York, East Hampton had become a relative backwater, frequented by artists and New York clergy. The extension of the tracks to East Hampton was welcomed by

most businesses, land speculators, farmers, and fishermen who would benefit from a reliable and efficient shipping route to the west. The artists and summer residents feared that the train would destroy their cherished serenity and that the world as they knew it would never be the same. In a way, they were right. On June 1, 1895, the first train pulled into East Hampton, and the stage was set for its emergence as a fashionable resort.

The summer colony grew steadily in the first three decades of the 20th century, attracting an eclectic cross section of wealthy Americans. The community distanced itself from the more formal and ostentatious development occurring concurrently in Southampton. East Hampton was considerably smaller in size and was not as closely tied to old New York society. The influx of visitors led almost immediately to the construction of several new hotels and all the services needed to sustain summer visitors. With the subdivision of the home lots fronting onto Main Street, new lanes like Dunemere and Huntting provided small but comfortable plots for traditional shingle-style homes. Toward the beach, Lily Pond Lane and Lee Avenue offered larger land parcels for small estates. On the Eastern Plain, toward Amagansett, three great houses defined what was possible when wealth, architecture, and landscape architecture connected. The Frank Wiborg house on Highway Behind the Pond, the C.C. Rice house on Hither Lane, and the Robert Appleton house on Old Beach Lane all commanded exceptional views of the water and village, and were substantial properties unto themselves. At the opposite end of the village, literally on Georgica Pond, architect Grosvenor Atterbury designed East Hampton's most legendary estate, the Creeks, for the Herter family. With just three colorful owners in 100 years, it is the best remaining example of a vanished way of life.

The stock market crash of 1929 and following years slowed development in East Hampton to a trickle. While the summer colony quietly carried on, few large, new homes were built; several existing ones were razed or destroyed by fire. East Hampton again fell into a quiet slumber and remained a farming and fishing community at heart.

As the Long Island Expressway pushed eastward in the 1960s, the tedious four-hour drive from Manhattan on a patchwork of roads was gradually cut in half. This set the stage for the third invasion, this time of well-to-do second home owners who could now become weekenders. Mostly New Yorkers, they increasingly came to view East Hampton as a year-round "country escape," rather than a 12-week summer resort. Their arrival dramatically altered the face of the community. While it has led to the restoration of many of the stately homes, it has also caused the development of both the open farmland and the surrounding woods. The local economy is now based on the myriad of individuals who keep these properties possible: developers, builders, landscapers, real estate agents, mortgage companies, lawyers, home furnishing stores, and an army of service staff. All scurry to satisfy the whims of an increasingly demanding clientele.

The development boom has been the subject of much discussion for 25 years. Over that period, an acre of farmland selling for $10,000 in 1960, $40,000 in 1970, and $125,000 in 1980, would bring $500,000 as a building lot in 2000. With the very real prospect that developable land has already run out, a new sense of urgency faces the community. Preserving its ancient identity and retaining the sense of place that has shaped it for over three centuries is by far its biggest challenge yet.

—Chip Rae
February 15, 2000

One
MAIN STREET

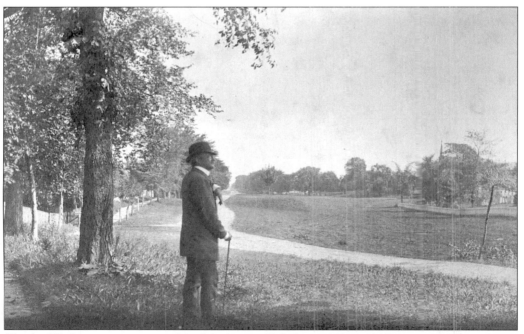

Charles W. Stewart, manager of the Maidstone Club from 1902 to 1930, gazes at Village Green from the sidewalk in front of the Maidstone Arms. To the right is the South End Cemetery, and in the distance is the commercial center of the village. (East Hampton Library.)

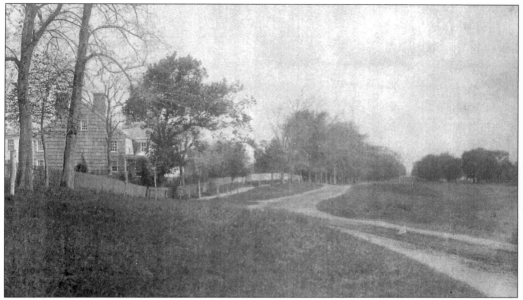

This similar but slightly earlier picture (*c.* 1900) of Main Street, now Route 27, shows a narrow dirt road with grass growing down the center. The road stretches from the corner of today's Mill Hill Lane toward the business district. Picket fences once lined the length of the street, separating the sidewalk from properties. (East Hampton Library.)

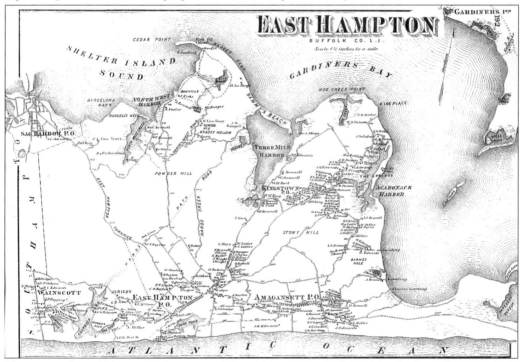

Shown on this 1873 map is the town of East Hampton, which surrounds the village on three sides. Outlying villages shown include Wainscott, Amagansett, and Kingstown (now Springs). Also included as part of the town is Gardiner's Island. Montauk, to the far right, is not shown. (Beers, Comstock, & Cline. Atlas of Long Island. 1873.)

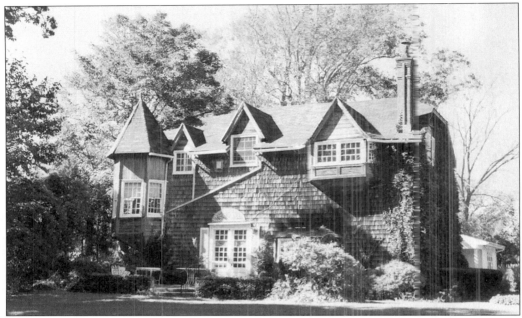

Well-known American artists Thomas Moran and his wife, Mary, first summered in East Hampton in 1878, six years before building a summer house and studio at 229 Main Street, opposite Village Green. The two-story, shingle-style house has been left to Guild Hall by its current owner. (Author's archives.)

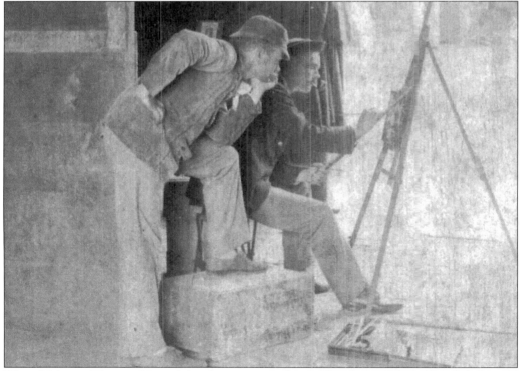

Edward Moran, Thomas Moran's brother, paints at his easel in front of Aunt Phoebe's barn in 1886. Another artist, Frank Russel Green, observes. (East Hampton Library.

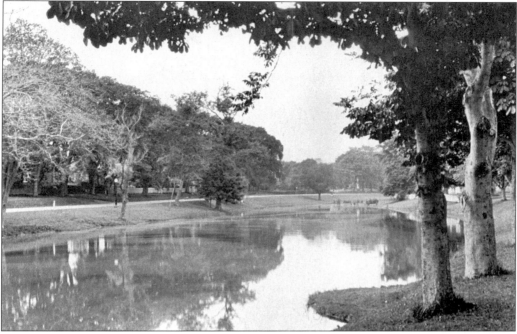

Located between Main Street and James Lane, Town Pond derived its earlier name, Goosepond, from the geese it attracted. Originally a marshy depression, it was excavated by early settlers to provide water for cattle. On the James Lane side of the pond is the cemetery. Across the lane are many early structures, including the Gardiner Mill; Home, Sweet Home; Pantigo Mill; and the Mulford farm. (Nassau County Museum Long Island Studies Institute.)

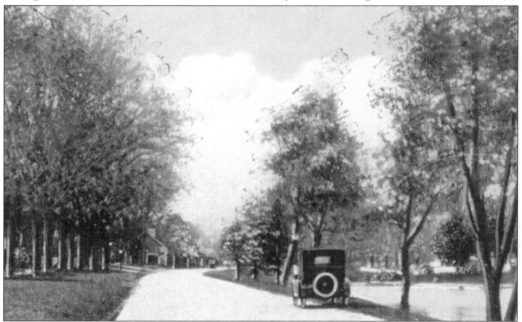

A vintage car pauses for its occupants to admire the view of Town Pond. Other cars are visible in the distance heading toward the village on Main Street, which is flanked by elm trees. (Harvey Ginsberg postcard collection.)

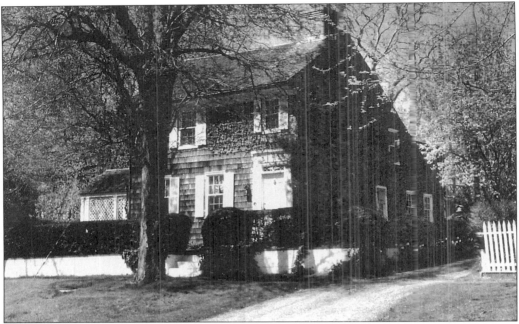

Aymar Embury II (1880–1966), a prominent architect, designed the Elizabethan-style public library, Guild Hall, the Lorenzo Woodhouse mansion, and numerous houses in the first decades of the 20th century. In 1929, he purchased the Issac W. Miller residence at 223 Main Street for his summer residence and updated it with modern conveniences and Colonial Revival details. (East Hampton Library.)

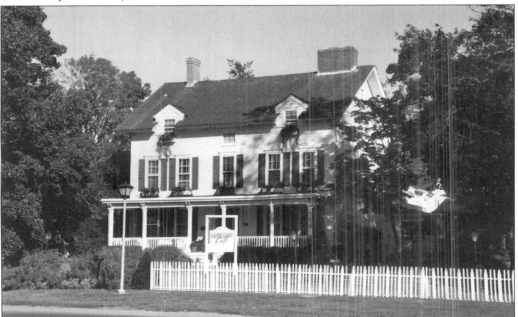

The two-and-one-half-story house at 74 James Lane was built in 1873 by John D. Hedges, whose family owned the land from 1652 to 1921. Mrs. Harry L. Hamlin acquired the house in 1935, renovating it and enlarging it into an inn. In 1954, she sold it to Henri Soule of New York's Le Pavillion, who made it a famous summer restaurant. (Author's archives.)

This two-and-one-half-story house, built *c.* 1840, remained in the Osborn family until 1924. It is known for having the purest Greek Revival trim in East Hampton. It is actually two buildings that were joined by a long front porch. (Author's archives.)

The house at 207 Main Street, seen in this more recent photograph, was acquired from the Osborn family by the Hampton Hotels Corporation in 1924. The new owners renamed it the Maidstone Arms. The inn is the site of the Osborn tannery, which was begun by Thomas Osborn in 1660. Originally opposite the tannery on Village Green was the Pantigo mill, later moved to Pantigo Road and to Home, Sweet Home in 1917. (Maidstone Arms.)

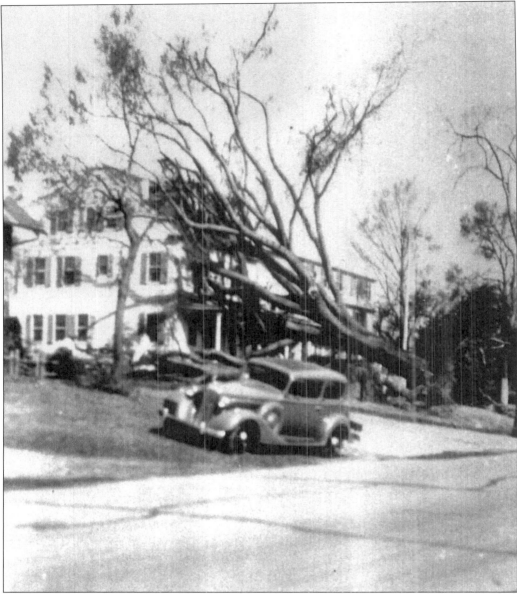

A large elm tree, uprooted by the Hurricane of 1938, rests against the front of the Maidstone Arms. Scores of elm trees throughout the village suffered extensive damage. According to a survey, 42 percent of the elms along the east side of Main Street were downed. The hurricane caused the death of 16 people in East Hampton. (C.E. King Jr. archives.)

Throughout the 19th and 20th centuries, the subdivision of the original home lots facing Village Green created many of the village's residential streets. Mill Hill Lane, pictured here, was developed in 1928. Lots were offered as "the only restricted property in East Hampton." Today, the street is best known for its magnificent sycamore trees. (Dan Powers.)

The first houses built on Mill Hill Lane were traditional and in the shingle style. Pictured on this 1938 Christmas card is 19 Mill Hill Lane, the fourth house completed on the street. It was built in 1929 for Jim and Helen Hildreth. During the Depression and for a short while in the early 1930s, the street became known as Mortgage Hill because many homeowners could not make their mortgage payments. (Jay Moorhead and Dan Powers.)

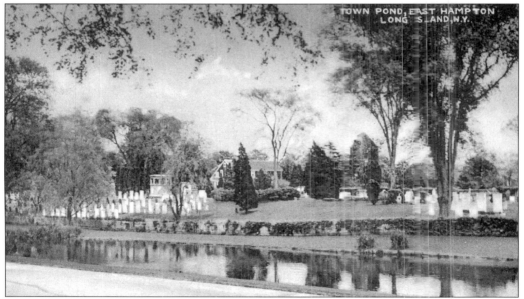

This view shows Town Pond and South End Cemetery from Main Street, c. 1930s. Many of the old homes in the background on James Lane (a street named for Rev. Thomas James, East Hampton's first minister) survive today. The original gravestones in the cemetery, which is surrounded by a picket fence, date to 1650. (Author's archives.)

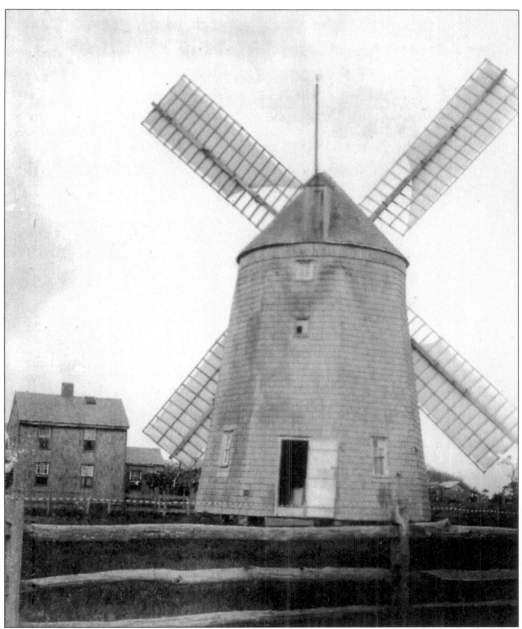

Constructed in 1804 on the east side of Town Pond, the Gardiner Mill cost $1,320—more than any residence in the village was worth at that time. Built by Nathaniel Dominy V from timbers cut on Gardiner's Island, it operated until the Hurricane of 1938 ripped off its arms. (East Hampton Library.)

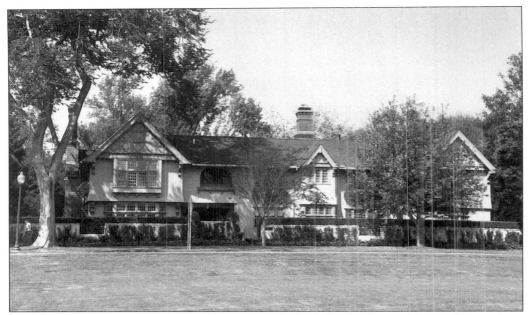

Now operated as an inn, Mrs. Eleanor Papendiek purchased this house at 18? Main Street from the Miller family in 1885. She had alterations made to the lean-to type dwelling, including a two-story addition in 1892. It was remodeled into a shingle-style cottage in 1899 by James Harper Poor. Architect Joseph Greenleaf Thorp gave the home its present Elizabethan appearance in 1911. (Author's archives.)

The formal gardens and terrace of the J. Harper Poor estate can be seen in this c. 1920 image. In the center is a large wading pool, flanked on each corner by an urn with flowers and vines. Today, the gardens have been restored to their original splendor. (Gary Reiswig.)

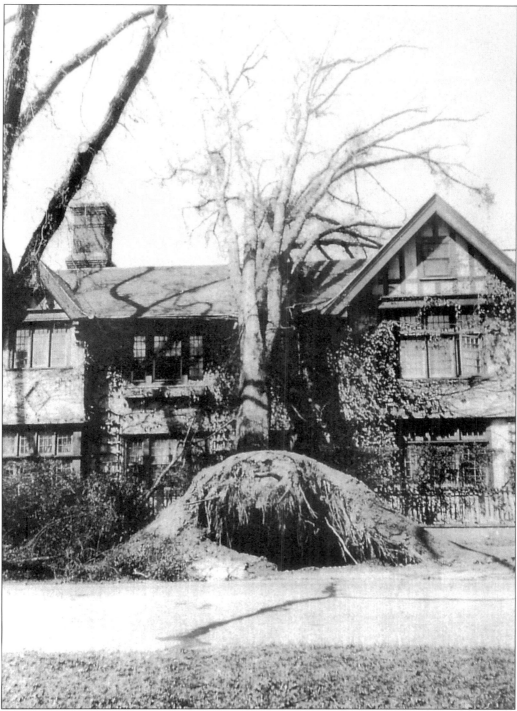

This American elm tree, uprooted by the Hurricane of 1938, rests on the center section of the roof of the J. Harper Poor cottage. The estate originally included the mansion, an extensive carriage house, terraces, and a formal garden. (Gary Reiswig.)

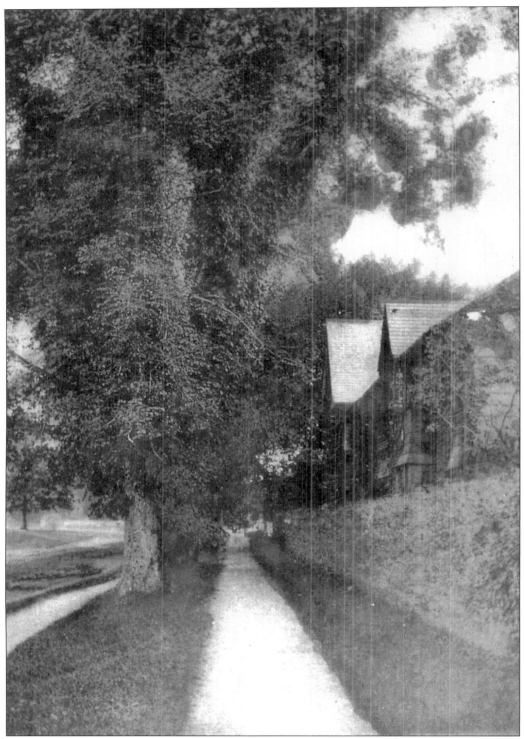

This 1905 image shows a sidewalk and a bicycle path that were separated by a grass strip in front of the J. Harper Poor cottage. American elm trees flanked Main Street in front of the house. (Gary Reiswig.)

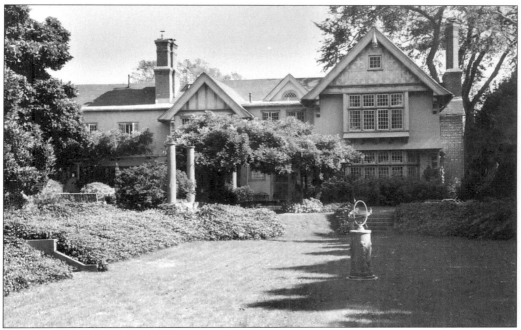

Shown are the cement steps leading to the sunken garden of the J. Harper Poor mansion. A boxwood parterre, ancient and overgrown, was reluctantly removed by the owners recently. The carriage house, appearing even larger than the main house, has been converted to a separate residence. (Gary Reiswig.)

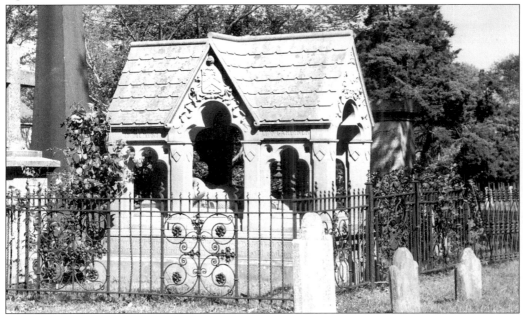

The most notable monument in the South End Cemetery is one commemorating Lion Gardiner (1599–1663), the first proprietor of Gardiner's Island. Erected two centuries after his death, it is a stone effigy of an armored soldier, hands folded in prayer, resting under a Gothic Revival arch that was designed by James Renwick. At the time of its installation, Gardiner's body was exhumed and reburied in the memorial. (Author's archives.)

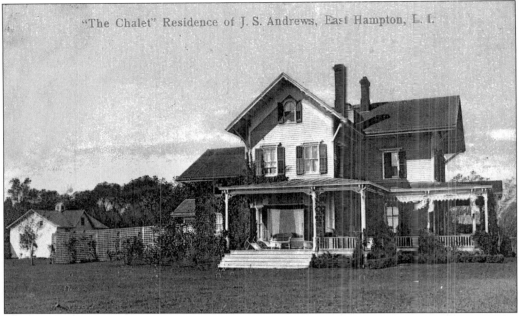

"The Chalet" Residence of J. S. Andrews, East Hampton, L. I.

In 1879, P.B. Jefferys built this chalet on James Lane next to his own home, Sommariva, for his brother-in-law, J.S. Andrews. It was extensively altered in 1899, when a large three-story wing was built by George A. Eldredge, a local builder. (Author's archives.)

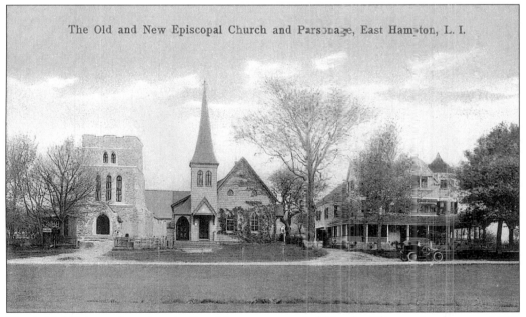

The Old and New Episcopal Church and Parsonage, East Hampton, L. I.

The initial Episcopal services in East Hampton were held in the Clinton Academy in 1855, three years before St. Luke's church, a small frame edifice, was built. To meet the growing needs of the congregation of summer residents, the church was enlarged in the 1880s and replaced by the present stone edifice on James Lane in 1910. Pictured are the new and old churches and the parsonage. Only the stone church remains today. (C.E. King Jr. archives.)

This idyllic image of the mid-18th-century house at 14 James Lane, the childhood home of John Howard Payne, was the subject of his song "Home, Sweet Home." In 1917, Gustav H. Buek moved the Pantigo Mill to the rear yard. East Hampton Village acquired it in 1927, preserving it as a museum. (Jay Moorhead and Dan Powers.)

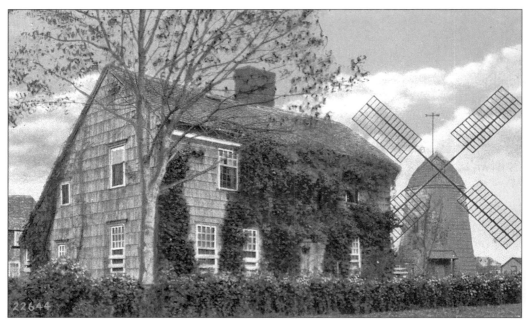

Home, Sweet Home was bought and remodeled to its original appearance in 1907 by Gustav H. Buek, a Brooklyn businessman who collected Payne memorabilia. The song that brought Payne lasting fame was composed when he was homesick and broke in Paris. This image was taken after Buek moved the Pantigo Mill to the rear yard of the house. (C.E. King Jr. archives.)

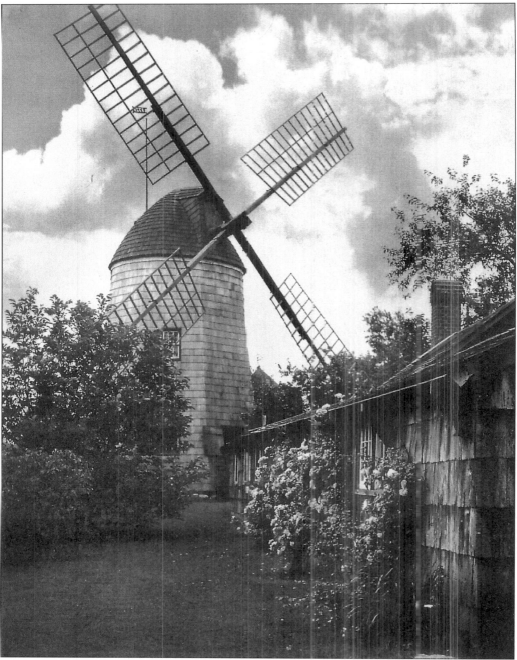

The 1771 Pantigo Mill's arms tower over the John Howard Payne house. The mill, originally located at the foot of Mill Hill Lane, sat on an artificial mound, which elevated it so it could better catch the breezes. It was moved to Pantigo Lane in 1850 and to Home, Sweet Home in 1917. (East Hampton Library.)

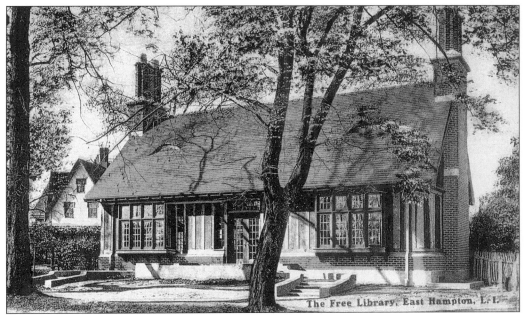

With the donation of books and funds by Mrs. Lorenzo E. Woodhouse, the East Hampton Library was founded in Clinton Hall in 1897, replacing a small collection of books in the home of Mrs. John D. Hedges. In 1911, the Woodhouses purchased the present site on Main Street and donated a new building that was designed by Aymar Embury II. The current library opened in 1912 and has been enlarged several times. (Harvey Ginsberg postcard collection.)

Built c. 1680 on James Lane by Josiah Hobart and acquired by Samuel Mulford in 1712, the Mulford house, one of the oldest houses on Long Island, remained in the Mulford family until World War II. In 1948, when the Brooklyn Museum proposed removing two rooms, residents raised $35,000 to purchase the property. It is now a museum operated by the East Hampton Historical Society. (Author's archives.)

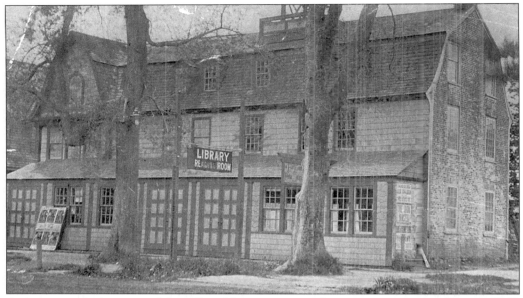

A sign notes the location of the village library in cramped one-room quarters at Clinton Hall, after its founding in 1897. It remained there until Mrs. Lorenzo E. Woodhouse's gift of land and funds were received to built a library on Main Street. The sign reads, "Library Reading Room." (C.E. King Jr. archives.)

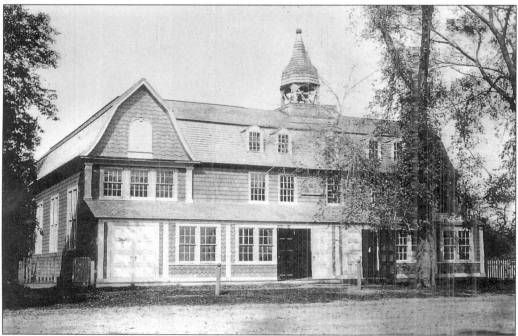

Chartered in 1787, the Clinton Academy on Main Street was the first accredited high school in New York State. Named after Gov. George Clinton, it prepared students for college. By 1881, it had fallen into disuse and in 1886, with the addition of an auditorium designed by James Renwick, it was converted into the village hall. Renovated by Mrs. Lorenzo E. Woodhouse in 1921, it is now a museum operated by the East Hampton Historical Society. (East Hampton Library.)

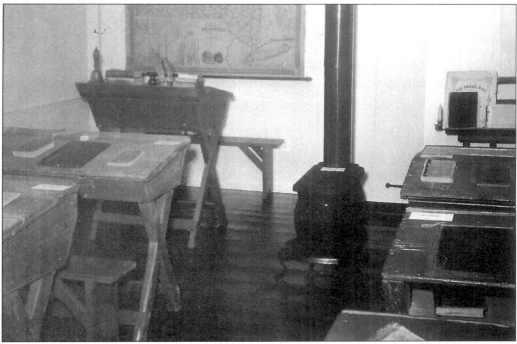

Shown are desks scarred by students' initials in the Town House. Heated in the winter by a pot-bellied stove, the school has had many uses. (East Hampton Library.)

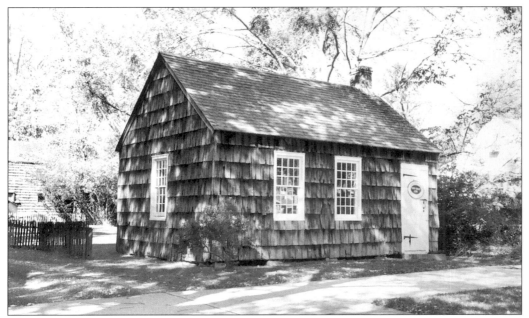

Built on the common on the north end of Main Street in 1733, the Town House served as a school and town meeting place. By the late 19th century, it had been moved to 117 Main Street and, in 1901, to a location behind the Methodist church. In 1958, the East Hampton Historical Society acquired it and moved it to 151 Main Street, next to the Clinton Academy. It is now a museum depicting an early classroom. (Author's archives.)

Designed by Aymar Embury II, Guild Hall, the site of the John Drew Theater and Woodhouse and Thomas Moran galleries, is a museum and theater complex at 156 Main Street. It was donated to the village in 1930 by Mrs. Lorenzo E. Woodhouse after the razing of the auditorium wing of Clinton Hall. The Charles Dewey wing was added in 1971. (C.E. King Jr. archives.)

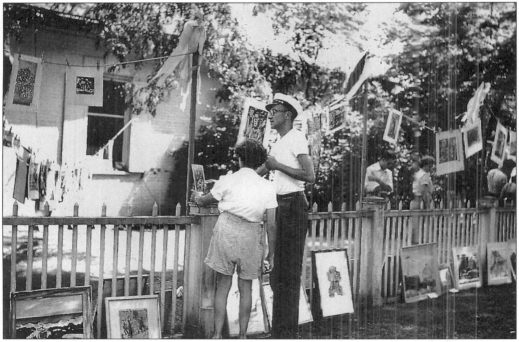

A couple pauses to admire a painting at an outdoor art sale at Guild Hall. The paintings, the majority of which are done by local area artists, are hung from a clothes line with clothes pins. Others in frames lean against the fence, which was removed long ago. (East Hampton Library.)

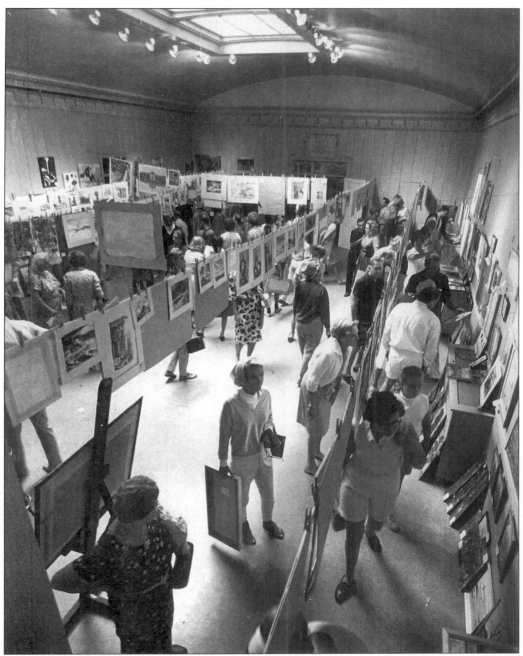

A popular attraction for summer residents, the clothes-art sale at Guild Hall draws hundreds of vacationers and area residents. Paintings, both oil and watercolor, include landscapes, buildings, florals, and portraits. Some are framed; others are not. In inclement weather, the sale is held indoors. (Guild Hall archives. Photographed by Joseph Adams.)

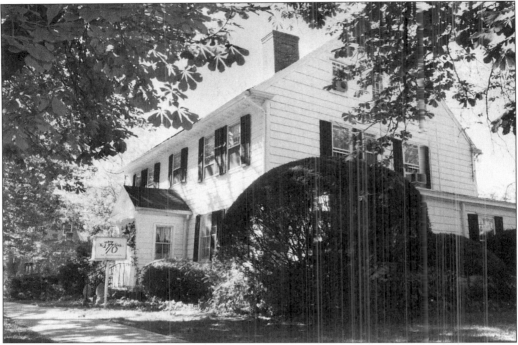

This house at 143 Main Street was possibly built in the late 1700s by Jonathan Dayton, who maintained a store in the south wing. With the conversion in 1942 to the "1770 House," the southwest corner of the original first story was enlarged and an addition was built in the rear. (Author's archives.)

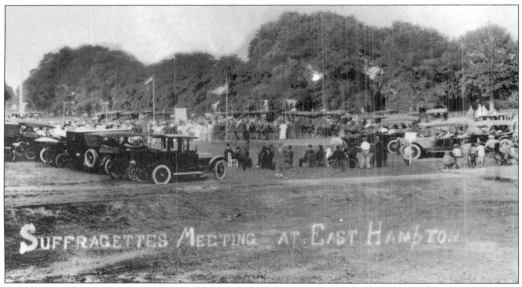

Suffragettes meetings were held on Village Green by the Woman Suffrage League of East Hampton as early as 1913. Speakers at an August 15, 1913 meeting included Mrs. Harriet Stanton Blatch, the president of the Women's Political League, and Miss Leonara O'Reilley, the president of the Woman's Trade Union League. The cars were driven onto Village Green from James Lane and Main Street to form a circle around the speakers. (Nassau County Museum Long Island Studies Institute.)

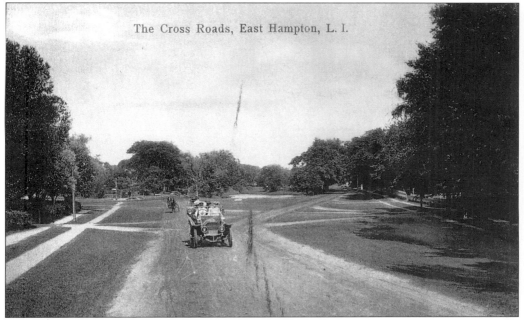

The Cross Roads, East Hampton, L. I.

Main Street, looking toward Town Pond from the present site of Guild Hall, was an open and grassy plain when this photograph was taken in 1907. The intersection of Main Street and Buells Lane was referred to as the crossroads for many years. (Harvey Ginsberg postcard collection.)

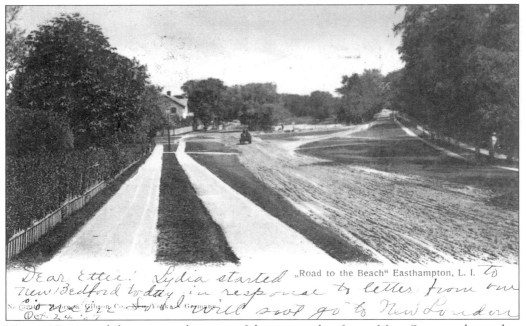

„Road to the Beach" Easthampton, L. I.

Dear Ettie: Lydia started new Bedford today in response to letter from our ... will soon go to New London Oct. 24 '07

This 1907 postcard showing another view of the crossroads refers to Main Street as the road to the beach. The picture shows shows a car heading toward the intersection of Woods Lane, with the eastern tip of Town Pond visible in the middle of the picture. (Author's archives.)

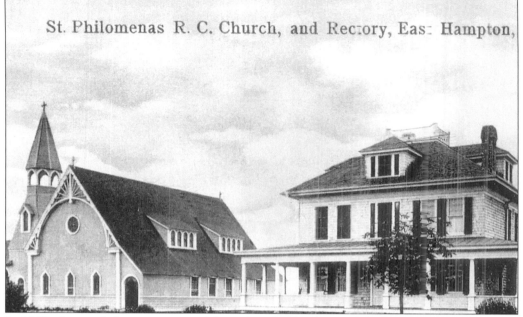

St. Philomenas R. C. Church, and Rectory, East Hampton,

In 1859, the area's first mass was celebrated in Sag Harbor's Methodist church. In 1894, St. Philomena's church was built at 79 Buell Lane at a cost of $7,400. The name was changed to the Most Holy Trinity Church in 1962. Alterations were made in 1897 and 1938, the year the steeple was damaged and subsequently shortened because of a hurricane. (Harvey Ginberg postcard collection.)

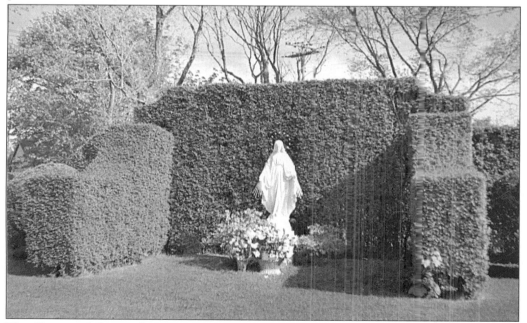

The Shrine of Our Lady of Grace on the grounds of the Most Holy Trinity Church is surrounded by flowers placed there by members of the congregation. The shrine was erected in 1963. The property on which the church and shrine stand was originally owned by the bishop of Brooklyn. (Author's archives.)

33

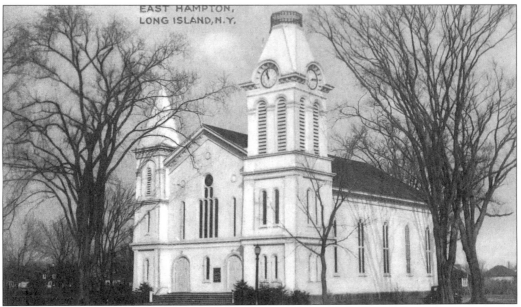

The First Presbyterian church, built in 1861 in the Romanesque Revival style at 120 Main Street, had two towers flanking twin entrances. It replaced a meetinghouse that had been built in 1717. Its construction was urged by Rev. Stephen L. Mershon, a revivalist minister and church pastor from 1854 to 1866. (C.E. King Jr. archives.)

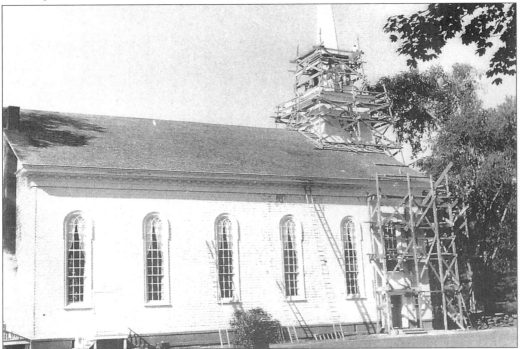

By 1960, the main facade of the 1861 Presbyterian church was in need of repair. Renovations, designed by Arthur Newman, altered its facade to the Colonial Revival style. The twin towers were removed and a new steeple and portico were added. The tower clocks were preserved and placed in the new steeple. (C.E. King Jr. archives.)

Taken before Main Street was widened and paved, the elm trees formed a canopy over the roadway. This c. 1920s picture shows the road bordered by a sidewalk and a bicycle path. The wooden hitching posts remained, even though they had certainly fallen out of use by this time. (Author's archives.)

The same view of Main Street looks east toward the business district in the 1950s. The street has been widened to four lanes to accommodate the increased number of automobiles. (Author's archives.)

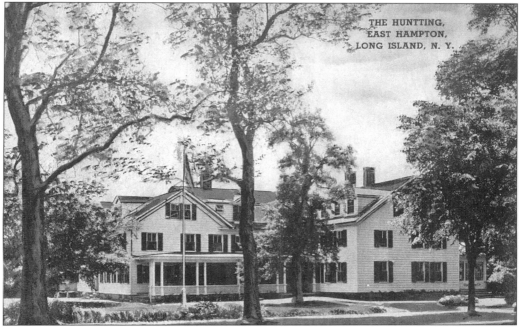

Opened as a public house in 1751 by Reverend Huntting's widow, the Huntting Inn at 94 Main Street, shown here in the 1940s, was considered neutral ground during the Revolutionary War. It was altered and converted into a boardinghouse in 1875. Today, it is probably best known as the site of the Palm restaurant. (Author's archives.)

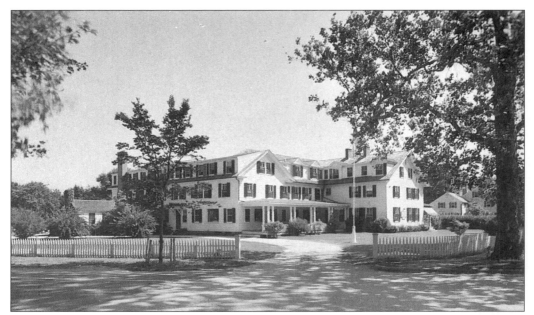

Located at the corner of Main Street and Huntting Lane, the present inn encloses a house built in 1699 for Rev. Nathaniel Huntting, East Hampton's second minister. Nine generations of Hunttings lived in the house, each making alterations and additions until the original structure was invisible. Pictured is the driveway from Huntting Lane to the main entrance, c. 1960s. (Author's archives.)

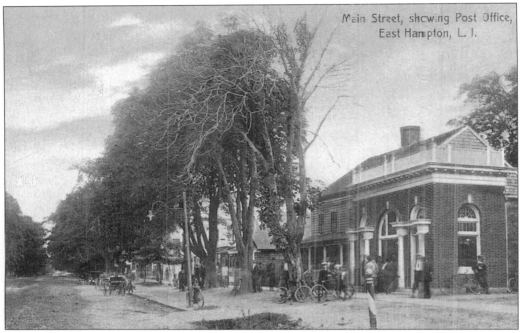

Built on Main Street, this post office succeeded one in the north wing of the Parsons house that was destroyed by fire in 1907. Designed by Joseph Greenleaf Thorp, this building remained in use as a post office until 1917. After many moves, a large facility was built on Gay Lane in 1995. (Author's archives.)

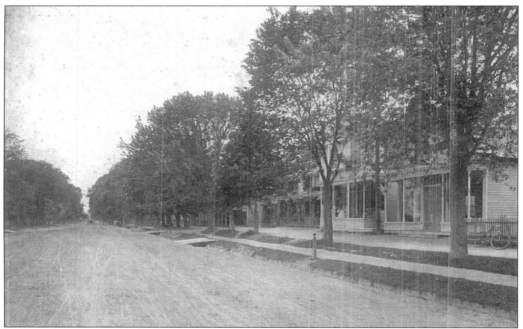

In 1906, Main Street was a dirt road with gutters crossed by wooden walkways at each store. Sidewalks had been introduced in the business district, but not to the edge of the road as today. A bicycle path and occasional hitching posts are visible. (East Hampton Historical Society.)

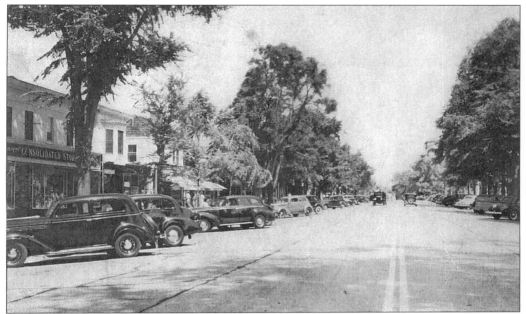

A view of Main Street (Route 27) looks east, c. 1940s. Note the cars parked at an angle to the curb; parking in this fashion was discontinued in the 1950s at the request of New York State to widen the street in order to accommodate the increasing number of cars. (East Hampton Historical Society.)

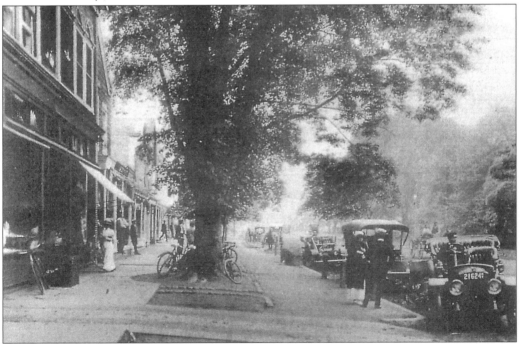

Originally, a tree grew in each of the squares set into the sidewalk on Main Street in the business district. The idea for the squares originated with a former mayor who liked the appearance of brick. Vintage cars are parked at the curb in front of the current Coach Store in this 1920s image. (C.E. King Jr. archives.)

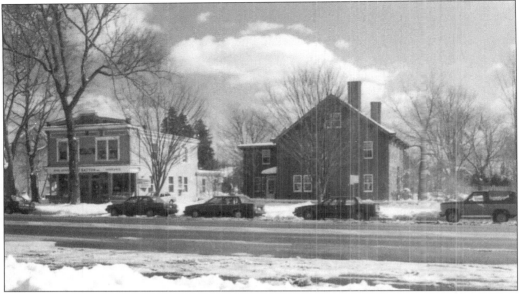

In the wintertime, the atmosphere of the village changes as traffic and shoppers diminish. Shown here is a section of Main Street after a snowstorm, c. 1970s, depicting the current village hall before its restoration. (C.E. King Jr. archives.)

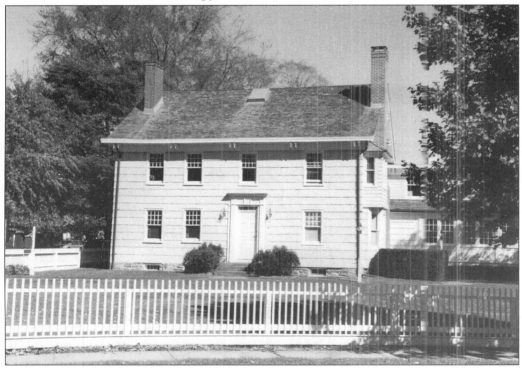

Now the East Hampton Village Hall, this house at 86 Main Street was built in the late 1700s. It was purchased in 1800 by Rev. Lyman Beecher, father of Harriet Beecher Stowe, who authored *Uncle Tom's Cabin*. The first village post office with 60 mailboxes was built behind this building in 1860. In 1994, the Village of East Hampton bought the house for use as a village hall at a cost of $900,000. (Author's archives.)

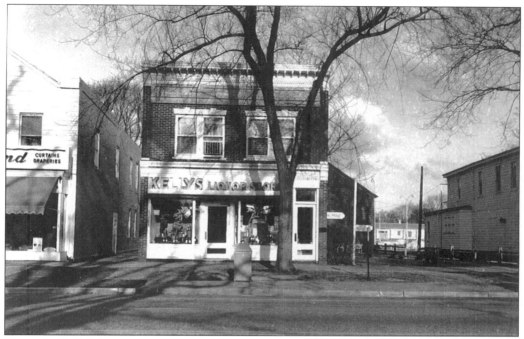

Shown is Kelly's Liquor Store (*c.* 1980) in a two-story brick building that was built in 1906 at 63 Main Street. The liquor store was in the front of the building on the west side of Main Street. Apartments were on the second floor. In later years, Tom Gilmartin's Meat Market was located in the rear of the building. (C.E. King Jr. archives.)

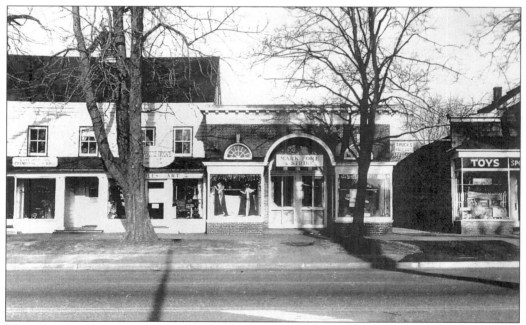

Shown is the Mark Fore & Strike store in the center of the Main Street business district before the store moved to larger quarters at the corner of Main Street and Park Place. On the right is an alley that now leads to a large parking lot behind the stores. (C.E. King Jr. archives.)

40

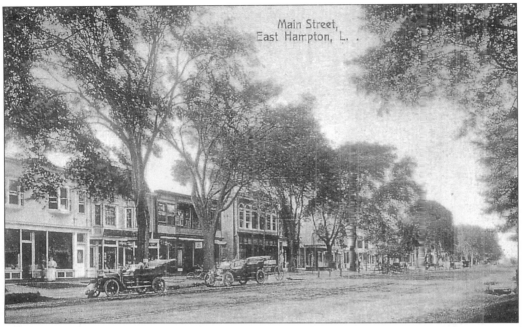

By the summer of 1909, cars had started to replace the horse and carriage as a means of transportation. Pictured are two early model touring cars, parked at the curbside of the still dirt Main Street in the center of the business district. A carriage is partially hidden from view by the second car. (Author's archives.)

Shown is an earlier view of the same stretch of stores on the north side of Main Street. The Ladies Village Improvement Society purchased horse-drawn water carts to water the dirt road daily to keep the dust down. On the far left, a house with a picket fence is a reminder of the homes that once dotted the stretch where the stores are. (Harvey Ginsberg postcard collection.)

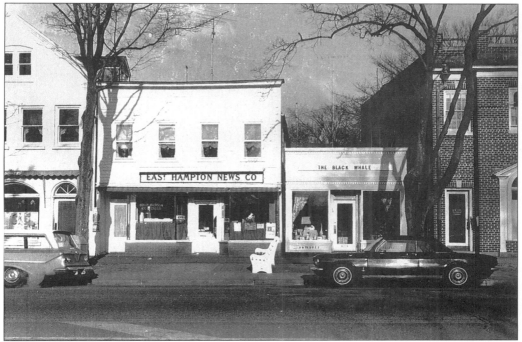

Shown is a two-story frame building on Main Street, the first floor of which was occupied by the East Hampton News Company and the second floor by apartments. To the right is the Black Whale antique shop. Pictured in the 1960s, the image shows a cement sidewalk bench. (C.E. King Jr. archives.)

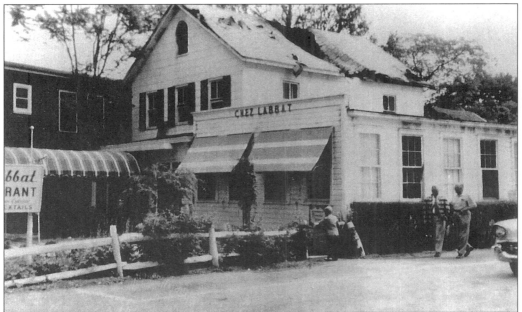

Located between the Edwards Theater and the Veterans of Foreign Wars Post building, the Chez Labbat restaurant was operated by Eugene and Marianne Labbat. A favorite oasis for all ages, it attracted the men of the Montauk Air Force Station in WWII. Today, the site is occupied by the two-story Cook Pony Farm real estate agency. (C.E. King Jr. archives.)

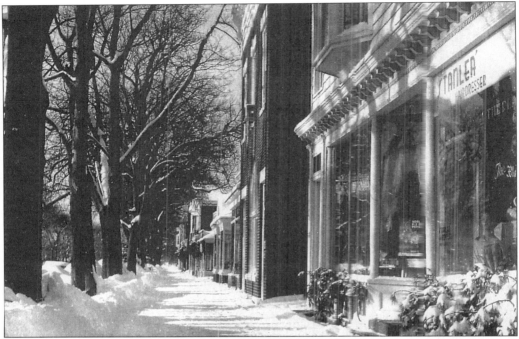

Looking south from Newtown Lane, the west side of Main Street with snow against the trees is devoid of shoppers. The frame building shown is currently the Polo Country at 33 Main Street, which underwent an extensive restoration at the time of its opening. (C.E. King Jr. archives.)

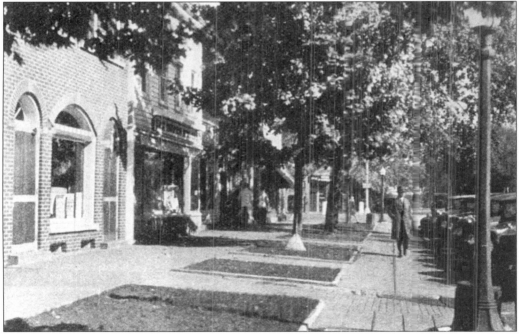

This view shows the wide sidewalk and stores on the west side of Main Street's business district, c. 1930. Though the businesses have changed, many of the storefronts remain the same today. Note the cars parked at an angle to the curb and an early street light. (Nassau County Museum Long Island Studies Institute.)

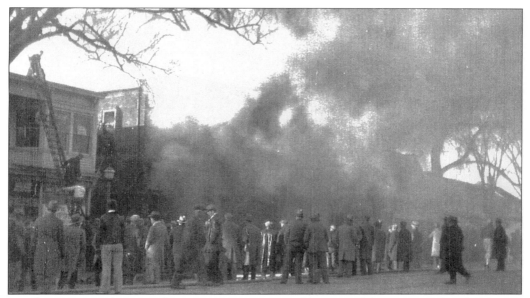

In February 1929, the OTG department store, operated by Samuel Gregory on Main Street, was gutted by a stubborn fire that drew scores of spectators. It took firemen from East Hampton, Southampton, Bridgehampton, and Amagansett four hours to control it. Damage was estimated at $60,000. East Hampton's new 1928 Maxim hook-and-ladder truck received its baptism at the blaze. (C.E. King Jr. archives.)

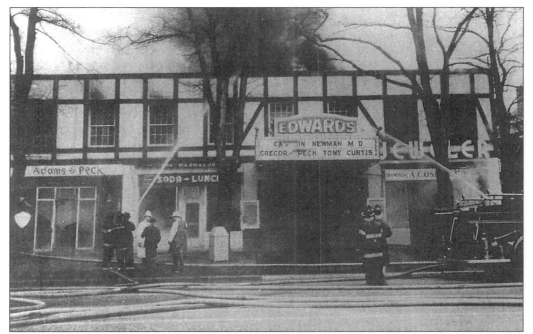

Constructed in 1938 by Roy Edwards, the Edwards Theater on Main Street had 1,035 seats, smoking lounges, and was decorated with tapestries and chandeliers. A youngster could enjoy a matinee for 15¢. It and six other businesses burned in a fire on April 14, 1964. A new theater was built at the location. (C.E. King, Jr. archives.)

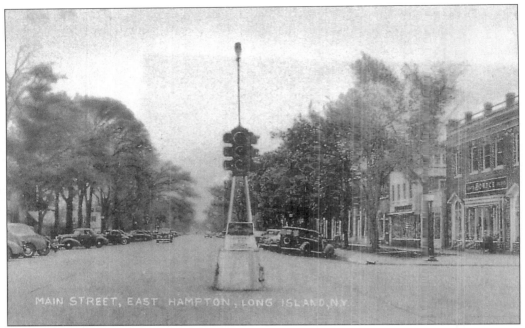

One of the earliest traffic signals in East Hampton is shown at the intersection of Main Street and Newtown Lane. Printed on its base are the words, "No turn on red." Motorists were still parking at an angle to the curb when this image was taken in the 1940s. Harvey Ginsberg postcard collection.)

Built in 1922 from a section of the old frame Union School moved from Newtown Lane to Main Street, the Masonic Temple later became the Veterens of Foreign Wars Post. The rear section later burned. At one time, the structure was owned by the village, which considered it for a village hall. It now contains stores. (Author's archives.)

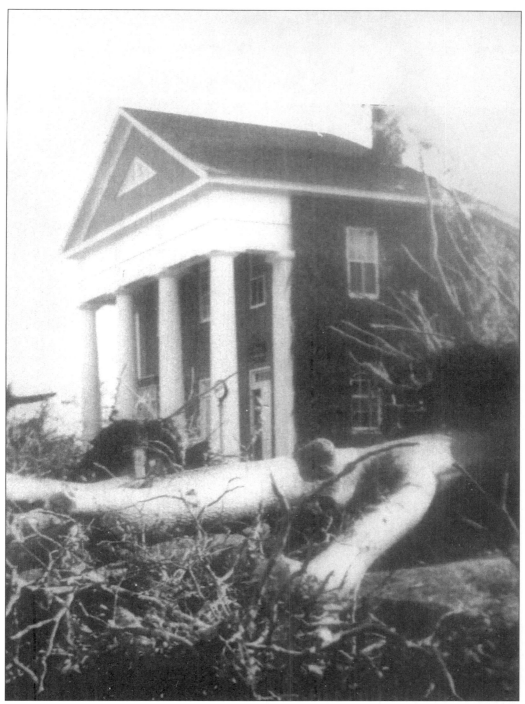

This large tree fell on a Buick sedan parked on Main Street in front of the Masonic Temple and crushed it during the Hurricane of 1938. Damage in the business district was sizable. Elm trees lay across Newtown Lane, while others rested on storefronts or on roofs. Sidewalks were ripped up and huge craters left where the tree roots had been. (C.E. King Jr. archives.)

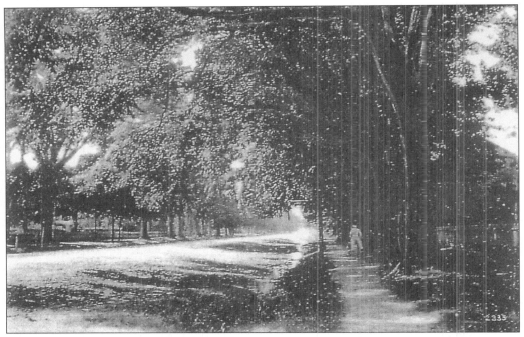

Trees formed a canopy over Main Street before the Hurricane of 1938. To save the American elm trees, the Ladies Village Improvement Society spearheaded a survival program developed by the Elm Research Institute. In 1980, the institute reported that "there is every reason to assume survival chances for the American Elm's of East Hampton are improved a thousand fold" as a result of the LVIS program. (Ladies Village Improvement Society.)

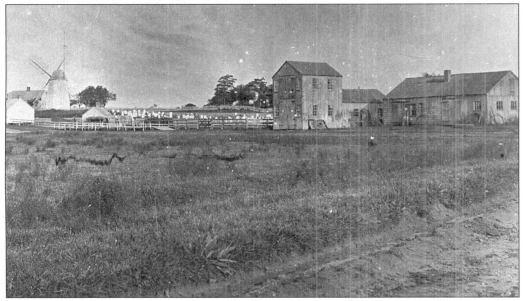

Pictured in 1879 is the Hook, a low-lying drainage basin that empties into Hook Pond. On the right is the James M. Strong blacksmith shop, which was started by his father-in-law, John H. Youngs, in 1846. In later years, the shop became a livery stable. The stable was leveled by fire on May 12, 1916, killing 17 horses. Behind it is the North End Cemetery, North End Schoolhouse, and Hook Mill. (Nassau County Museum Long Island Studies Institute.)

Egypt Lane, near the sheep pound, was bordered by farm fields that were separated from the narrow dirt road by split rail fences, c. 1900. One- and two-story shingle-style farmhouses and barns soon became prime property for summer homes. (East Hampton Library.)

The former Mark R. Buick garage and salesroom at 47 Pantigo Lane was built on the site of the James M. Strong blacksmith shop and livery stable. The stable burned in 1916, when a disgruntled employee set it afire. He was arrested, tried for arson, and sentenced to Sing Sing Prison. The building has remained empty for several years, awaiting commercial redevelopment. (C.E. King Jr. archives.)

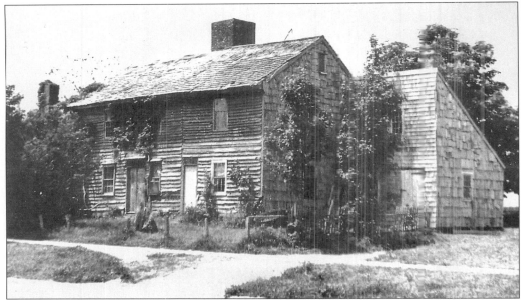

The Nathaniel Dominy house, built in 1715, stood on North Main Street on the site of the present IGA store parking lot. The first of three generations of fine craftsmen of clocks and furniture, Dominy initially had his shop in the house. Later, he built a semi-detached shop behind the lean-to-style house. (East Hampton Library.)

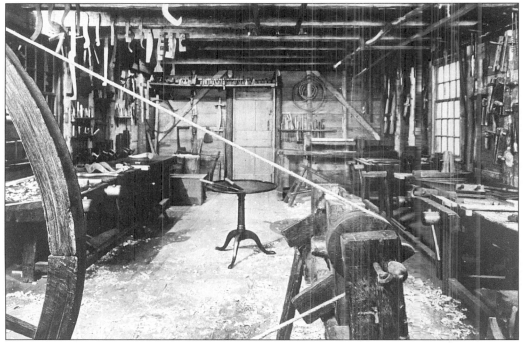

A replica of the shop where Nathaniel Dominy (1737–1812) made clocks and furniture was built at the Henry Francis du Pont Winterthur Museum outside Wilmington, Delaware, in 1960. The museum had purchased most of the tools from the workshop. The house was razed in 1947 and the clock shop sold to Dudley Roberts, who moved it to his home on Further Lane. (Nassau County Museum Long Island Studies Institute.)

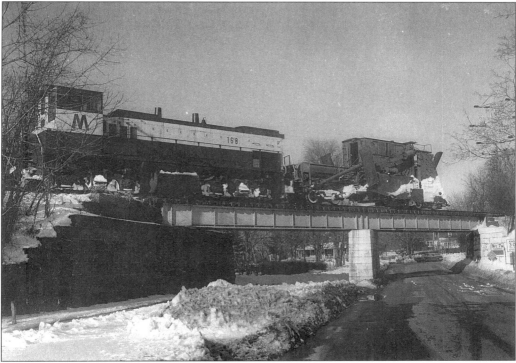

A diesel locomotive with a snowplow crosses East Hampton's North Main Street trestle, which dates to the turn of the century. Construction of the trestle divided East Hampton into two sections: "Below the Bridge" and "Above the Bridge." (Ron Ziel archives.)

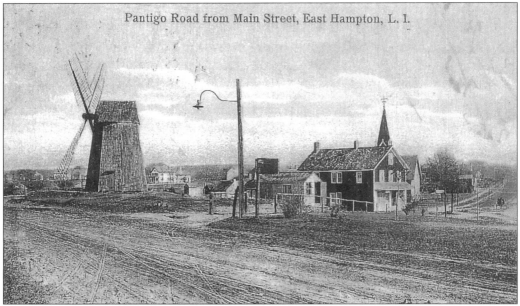

Pantigo Road from Main Street, East Hampton, L. I.

One of the main thoroughfares in East Hampton in the early 1900s, Pantigo Road (Route 27), was merely a dirt road then. It was part of the area referred to in early records as the "eastern plain," where herds of cattle and sheep were kept. On the left is Hook Mill and an early streetlight. (C.E. King Jr. archives.)

Two

Newtown Lane

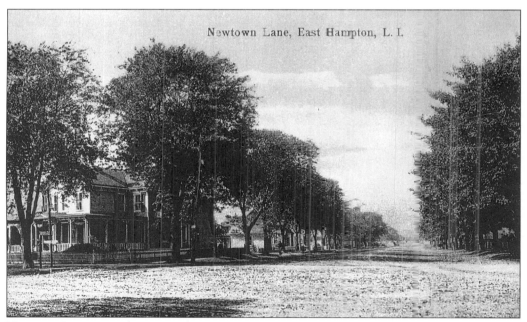

Newtown Lane, East Hampton, L. I.

Newtown Lane, stretching west from Main Street, is the second most important thoroughfare in the business district. At first, stores were mixed with houses, such as the one shown in this image. It was moved to Church and Gingerbread Lanes, like many other houses, to make room for stores (Harvey Ginsberg postcard collection.)

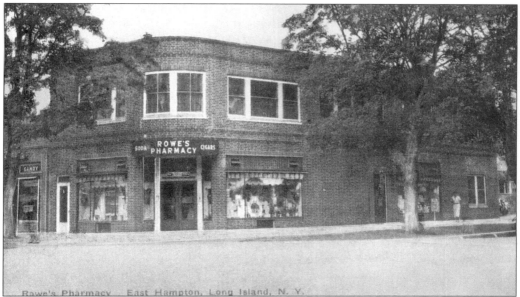

In 1921, Casper C. Rowe bought the drug business owned by E.J. Edwards, located in the building now occupied by the East Hampton Star. Two and one-half years later, Rowe moved to the Gilmartin Building in the business district to offer better service. The store closed in the early 1990s. (Harvey Ginsberg postcard collection.)

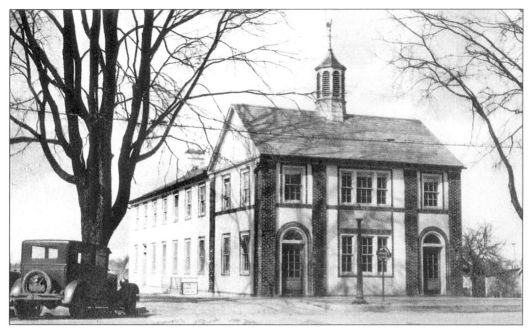

Designed by Robert Tappan, this two-story stucco building at 46–50 Newtown Lane has red brick trim, two entrances, and an imposing cupola. It became the village post office when an earlier one on Main Street could not handle the flow of mail. In 1960, postal facilities were moved to a new building on Gay Lane that has since been demolished. A new post office has since risen on the same site. Today, the Newtown Lane building houses the Barefoot Contessa speciality food store. (Harvey Ginsberg postcard collection.)

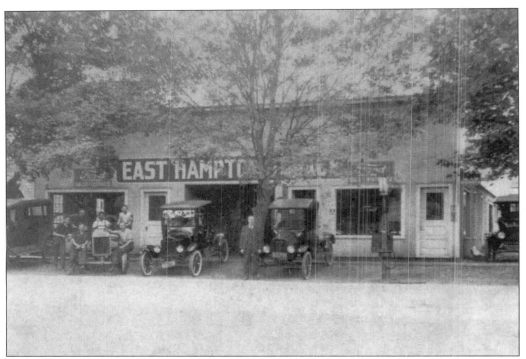

Shown is John Jensen's one-story East Hampton Garage on Newtown Lane, c. 1910, with a single hand-operated gasoline pump at the curbside. At the time, gasoline sold for 19¢ per gallon. Occasionally, garages ran specials: six gallons for $1 The garage is now the Ann Crabtree and Henry Lehr clothing store. (C.E. King Jr. archives.)

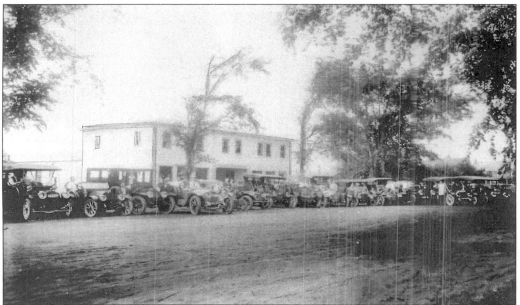

I.Y. Halsey's two-story garage on Newtown Lane, where Waldbaum's supermarket now stands, was built in 1907, destroyed by fire in 1910, and rebuilt. It operated for more than 50 years, until July 1959, when it was sold. The garage repaired everything from bicycles to cars, trucks, and airplanes. They sold Oldsmobile cars and Dodge cars and trucks. (C.E. King Jr. archives.)

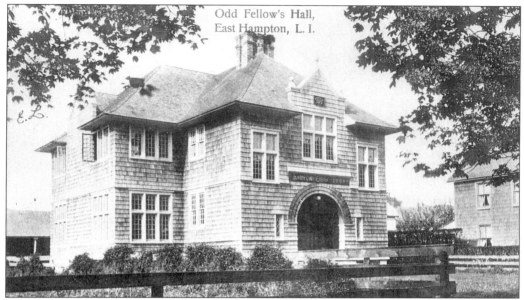

Odd Fellow's Hall,
East Hampton, L. I.

The East Hampton Odd Fellows Lodge was founded in 1890. It had 85 members in 1897, when this two-story shingle-style building, designed by Joseph Greenleaf Thorp, was built at 26 Newtown Lane. Set back from the street, it was originally painted dark green. Before becoming the Eileen Fisher store, the building was a school, an art gallery, and an arts center. (Harvey Ginsberg postcard collection.)

This three-story, shingle-style house was built in the early 19th century on Newtown Lane for Elisha Mulford. It was inherited by Adeline M. Sherrill in 1925, sold to Mrs. Nancy Seaman Barnes, and moved to the rear of the property, now Barnes Lane. It was later converted into apartments. (East Hampton Library.)

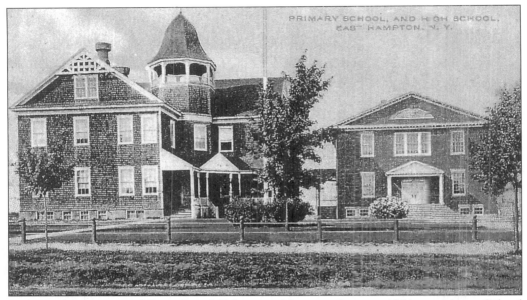

Built on the property of Capt. David Fithian on Newtown Lane in 1894, the Union School served students from Montauk, Amagansett, Springs, and Wainscott. In 1922, a section of the old school was moved to Main Street, where, after alterations, it became the Masonic Temple and later, the Veterens of Foreign Wars Post. The school's brick portion remained and became a wing of the present middle school. (Author's archives.)

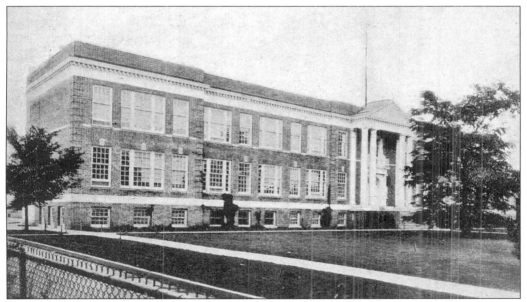

This two-story brick East Hampton High School building, constructed in 1923, is now the middle school. It has been enlarged several times and had its windows replaced. Originally, it contained a combination auditorium and gymnasium that seated 750 people. It also had 20 classrooms, a library, a large kindergarten room, a study hall, and a laboratory. (Author's archives.)

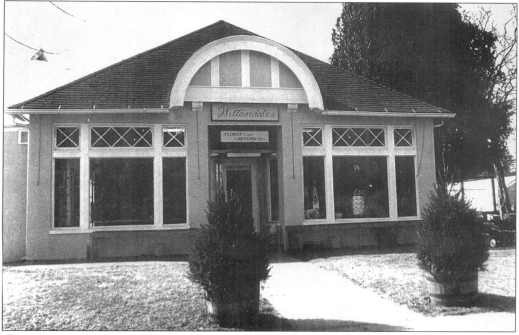

The design of the Vetault flower shop at 89 Newtown Lane is attributed to Joseph Greenleaf Thorp. Modernistic for its time, it was constructed in 1927. It later became Wittendale's Florist & Greenhouses, Inc. (Wittendale's Florist.)

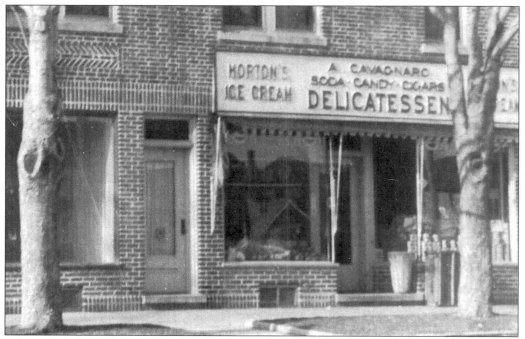

Albert Cavagnaro, a mason, had a three-story brick building constructed at 105 Newtown Lane in 1923. He opened a combination delicatessen and grocery store on its first floor. The upper floors were apartments. The left storefront has been home to several bars and grills, the last of which closed in 1994. (The Cavagnaro family.)

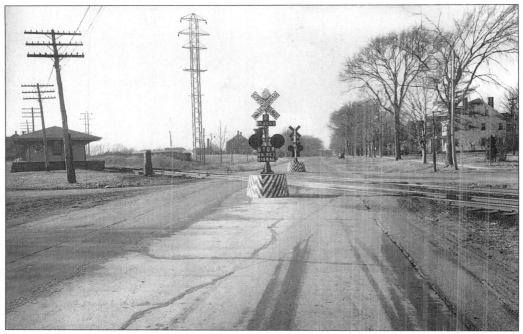

The railroad crossing warning lights at Newtown Lane are pictured on January 6, 1938. To the left on Railroad Avenue is the red-brick Express Agency Building, since razed, and beyond it, the railroad station. (Ron Ziel archives.)

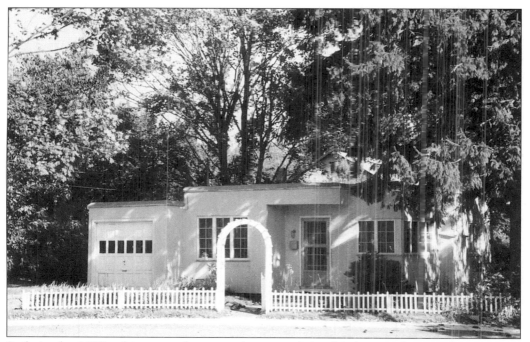

Built in the 1930s, this stucco house in the tropical Art Moderne style is at the corner of Sherrill Road and Newtown Lane. It was intended to be the start of a low-cost housing development proposed by a civil engineer and land surveyor from Mexico. The project failed, and only two houses were built. (Author's archives.)

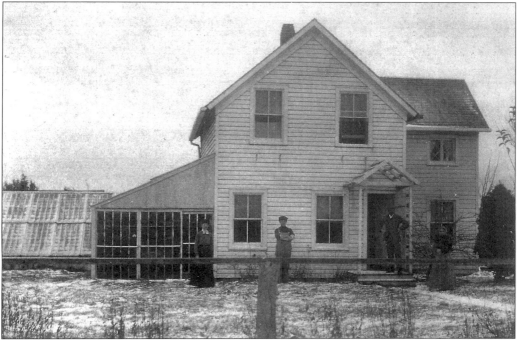

Located at the intersection of Newtown and Race Lanes, the George Lisberg greenhouses were one of East Hampton's first flower shops. In later years, it was the William H. Greene florist. This image shows a two-story frame house on the property after an addition on the north end enlarged the living room in 1902. In the background is one of many greenhouses. (C.E. King Jr. archives.)

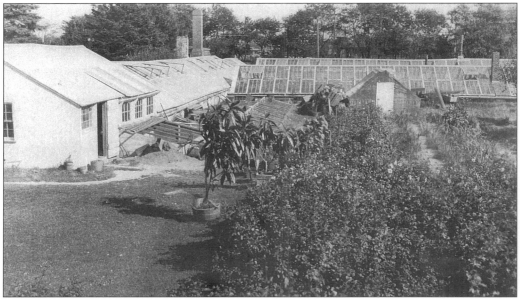

Shown are the Lisberg greenhouses in the early 20th century. On the left is the potting shed, work areas for starting seedlings, and the heating plant. The greenhouses were built by Lord & Burnham Company of Irvington-on-the-Hudson. The foundations are still visible today. (C.E. King Jr. archives.)

Three

EAST HAMPTON
STATION

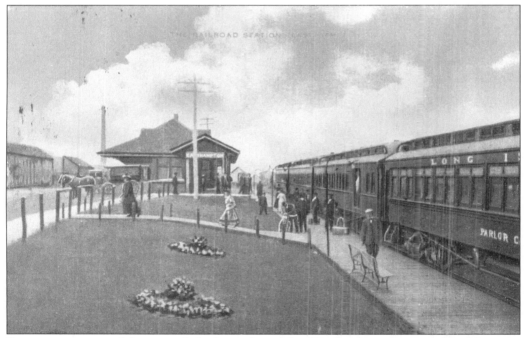

Passengers, many with luggage, alight from a Long Island Railroad steam train in East Hampton at the turn of the century. Horse-drawn livery carriages await them on Railroad Avenue. (Harvey Ginsberg postcard collection.)

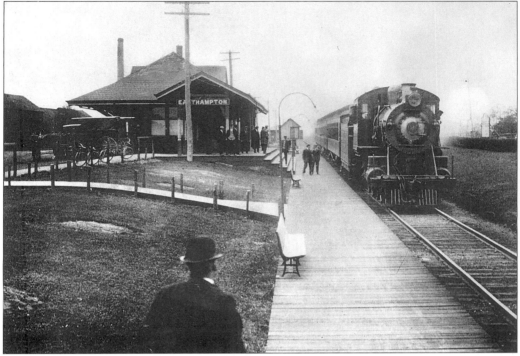

This 1910 image shows the red-brick East Hampton Railroad Station, since painted white, as a train arrives from New York. Note the wooden platform, vintage overhead lights, and horse-drawn livery carriages awaiting passengers. (Ron Ziel archives.)

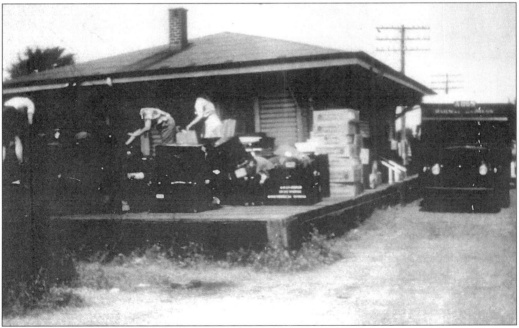

Girls en route to camp at Fireplace Lodge in Springs sort out their trunks on the raised platform of the Railway Express Agency Building. At the time, the agency used Clydesdale horses to pull their bright green delivery wagons. The building has since been razed. (C.E. King Jr. archives.)

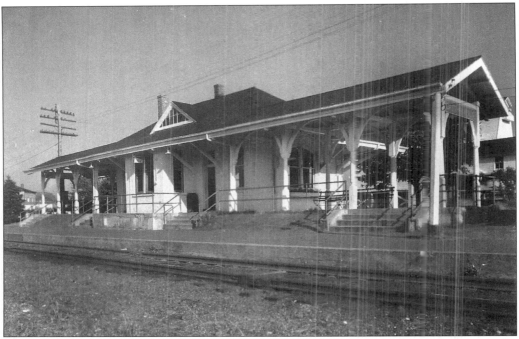

A trackside view shows the East Hampton Railroad Station that was built in 895, the year the Long Island Railroad's single track reached East Hampton. The railroad was the major cause of the influx of summer visitors at the turn of the century, creating a rooming shortage and necessitating the construction of hotels. (Dan Powers and Ron Ziel.)

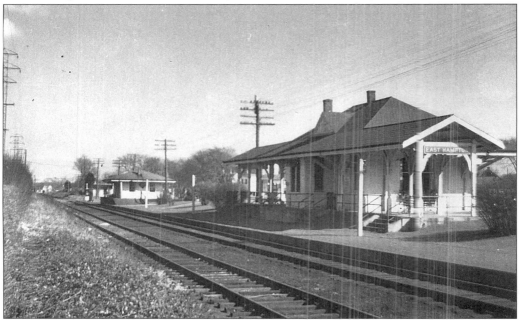

This trackside view shows the East Hampton Railroad Station on February 21, 1949. The red bricks used in its 1895 construction have been painted white, and the wooden platforms are replaced by cement platforms. Beyond it is the Railway Express Agency building with its high platform. (Ron Ziel archives.)

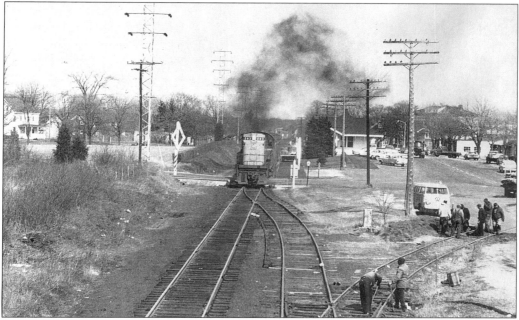

A diesel locomotive crosses Race Lane, the former site of the freight building, as it leaves East Hampton heading east. Workmen in the foreground and at the right are repairing sidings from the main track. One track led into the lumberyard and coal elevator opposite the train station. The sidings have been ripped up. (Ron Ziel archives.)

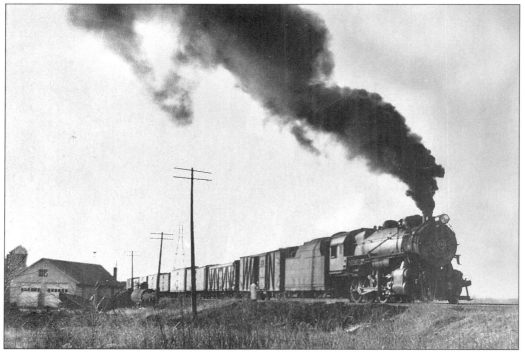

A steam engine belching smoke pulls freight cars loaded with potatoes. They were grown by farmers in the East Hampton area and shipped westward to market. The large garage on the left was the East Hampton Road Department garage on Gingerbread Lane. (Ron Ziel archives.)

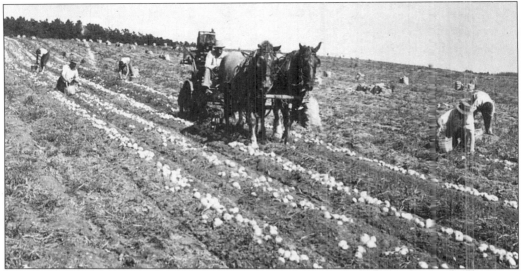

A horse-drawn plow digs furrows in potato fields at harvest time in the 1930s. The workers are bagging the exposed potatoes for shipment to market in railroad freight cars pulled by steam engines. Rows of bags filled with potatoes litter the field while the empty bags wait to be filled. Although potatoes were once Long Island's major crop, potato fields are now are rare sight. (Nassau County Museum Long Island Studies Institute.)

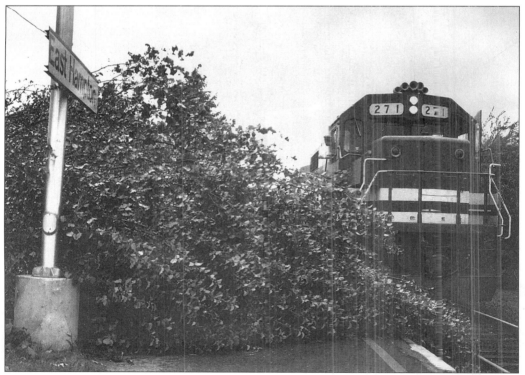

Diesel locomotive No. 271 is halted short of the East Hampton Railroad Station by a tree knocked down by Hurricane Gloria on September 27, 1985. (Ron Ziel archives.

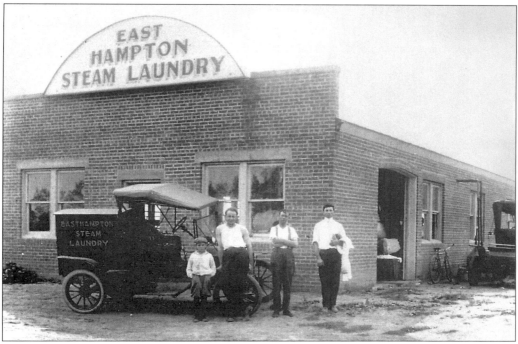

Pictured in 1913, the one-story brick building at 31 Race Lane was home to the East Hampton Steam Laundry. In 1980, a restaurant by the same name opened in the building, carrying over its past use into the present. There is an old wringer washing machine at the entrance and parts of a primitive dryer in the garden. (C.E. King Jr. archives.)

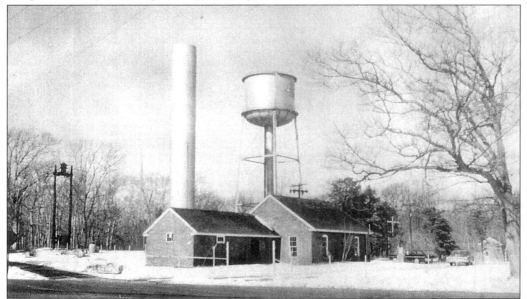

When the Suffolk County Water Authority purchased the Home Water Company in 1963, a new water storage tank was built behind the East Hampton Town Hall to serve the village and town. At the time, the old water tank and stack on Route 27 (pictured) were razed. Two brick buildings remain, the largest of which has a deep cellar where a steam engine generated power. (C.E. King Jr. archives.)

Four

THE LADIES VILLAGE IMPROVEMENT SOCIETY

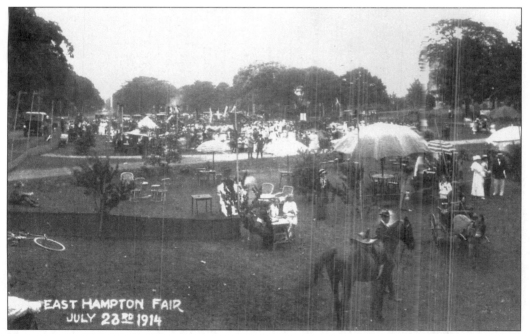

Shown is the 19th fair held by the Ladies Village Improvement Society on Village Green, July 23, 1914. The fairs raised funds for numerous village improvements. This was one of the last fairs held on Village Green because of the trampling of the grass. After 1915, fairs were held at the Mulford farm on James Lane, which overlooks Village Green. (Ladies Village Improvement Society.)

The Gardiner–Brown house at 95 Main Street (now the headquarters of the Ladies Village Improvement Society) was built in 1740 by David Gardiner, the fourth proprietor of Gardiner's Island. In 1924, Winthrop Gardiner moved it back on the property, remodeled the house, and enlarged it. The fence separating the house from the sidewalk remains today, although it has seen many repairs over the years. (East Hampton Library.)

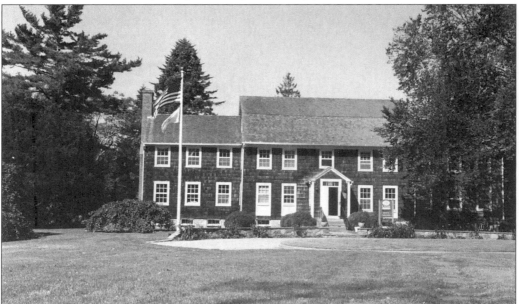

In 1950, 26 years after moving it back from the street and establishing a large front lawn, Winthrop Gardiner sold the house to Lawrence A. Baker. After a bad fire and much speculation, the house was renovated in the 1980s for the Ladies Village Improvement Society headquarters. (Author's archives.)

Although most elements of the present fence on Main Street have been replaced, the design of the fence remains unchanged from the late 19th century. Probably built by Gardiner, it was rebuilt twice in the 20th century. (Author's archives.)

American elm trees planted on both sides of Main Street and Newtown Lane formed a canopy over the dirt roadways in the early 1900s. Many were uprooted by the Hurricane of 1938. Others, aided by a program financed and sponsored by the Ladies Village Improvement Society, fight for survival from the Dutch Elm disease. (Ladies Village Improvement Society.)

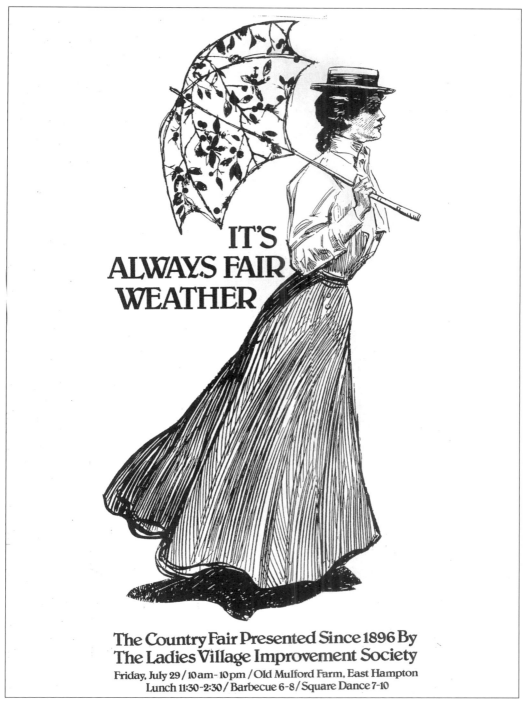

IT'S ALWAYS FAIR WEATHER

**The Country Fair Presented Since 1896 By
The Ladies Village Improvement Society**

Friday, July 29 / 10 am - 10 pm / Old Mulford Farm, East Hampton
Lunch 11:30-2:30 / Barbecue 6-8 / Square Dance 7-10

This poster for the Ladies Village Improvement Society's fund-raising fair presents the slogan used since 1896: "It's Always Fair Weather." Chartered by 22 women in 1895, the LVIS initially funded lighting for Main Street and horse-drawn water carts to eliminate dust from the dirt road. Since 1978, it has taken the lead in preserving and planting trees. (Ladies Village Improvement Society.)

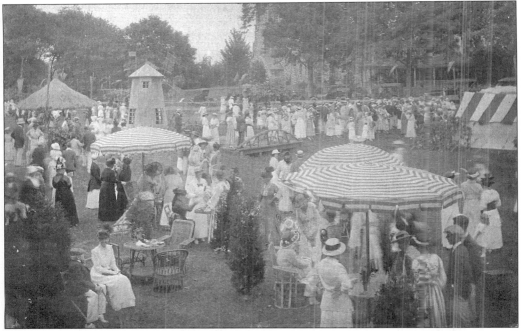

Shown are tables (many with umbrellas and wicker chairs), tents, and a miniature windmill scattered on Village Green in July 1915 for the 20th annual fair sponsored by the Ladies Village Improvement Society. The initial fund-raising event held by the group, a New England supper and klondike auction, was held three months after its founding on January 28, 1896. (Ladies Village Improvement Society.)

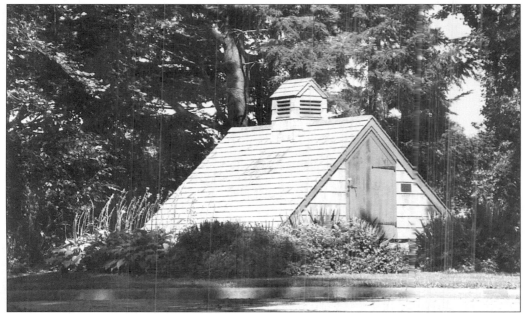

The first full two-story two-room deep icehouse in East Hampton, the Gardiner ice house is one of two 19th-century icehouses remaining in the village. It is the only reminder of the property when David Gardiner operated extensive agriculture pursuits on a large farm. (Author's archives.)

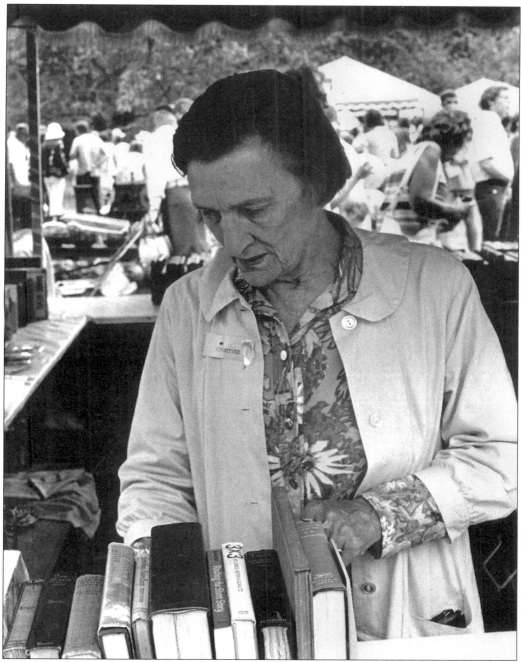

Helen Hull Jacobs arranges books in the book booth at the 1973 fair. The Ladies Village Improvement Society instituted the fair as a fund-raiser in 1896. One of its first projects was lighting Main Street in 1898, when it hired a lamplighter and bought 56 streetlamps, lamp posts, and lamp oil. (Ladies Village Improvement Society.)

LADIES VILLAGE IMPROVEMENT SOCIETY
54TH ANNUAL FAIR

FRIDAY, JULY 29th, 1949

on the MULFORD FARM

FAIR	COUNTRY DANCE
One to six p.m.	eight p.m.

LADIES' ANNUAL BASEBALL GAME
Sunday, August 7th, 4 p.m. — Maidstone Club
(S. Kip Farrington, Jr., *Chairman*)
Ruth Maguire's "Yankees"
vs.
Betty Robert's "Dodgers"

FAIR COMMITTEE

Chairman	Mrs. Thomas S. Nichols
Vice-Chairman	Mrs. Edward Tillinghast
Treasurer	Mrs. Donald R. Carse
Construction Chairman . . .	Mrs. Louis F. Bishop, Jr.
Executive Advisory Group . . .	Mrs. Juan T. Trippe
	Mrs. Russell Hopkinson
	Mrs. Edward Ewen Anderson
	Mrs. Harry D. Watts

COMMITTEES

APRON BOOTH
Mrs. A. Victor Amann, *Chairman*

Miss Frances Ford	Mrs. Harry Escalette
Mrs. Norman Quarty	Mrs. Willard Livingston
Mrs. Edwin Heller	Mrs. Charles Glock
Mrs. Amelia Reininger	Miss Adaline Sherrill

BALLOONS
Mrs. Lawrence Flinn, *Chairman*

CAKE BOOTH
Mrs. William T. White, *Chairman*

Mrs. Leon Q. Brooks	Mrs. Ralph Kennedy
Mrs. Andrew Carson	Mrs. J. C. Lawrence
Mrs. Ernest Clifford	Mrs. J. H. Mulford
Mrs. A. Norman Gould	Mrs. Charles Peale
Mrs. John Grant	Mrs. Norman Quarty
Mrs. Frank Jewels	Mrs. H. G. Stephens
Mrs. I. Y. Halsey	Mrs. N. N. Tiffany, Sr.
Mrs. Julis Hand	Miss Adaline Sherrill

CANDY AND CIGARETTE BOOTH
Mrs. Hugh J. Robertson } *Co-chairmen*
Mrs. Oswald Jones

FLOWER BOOTH
Miss Martha A. Burke, *Chairman*

Mrs. Scott McLanahan	Mrs. Darwin Kingsley
Mrs. Archibald Reid	Mrs. Joseph Rammee
Mrs. Daniel Tenney	Miss Gertrude Behr
Mrs. Frank Carr	Miss Edra Nash
Mrs. Arthur Terry	Miss Amy Knox
Mrs. Paul Lennon	Miss Marguerite Hoguet
Mrs. Louis Bock	

ENTRANCE GATES
Mrs. Norman Barnes, *Chairman*

Mrs. Benson Jones	Miss Catherine Edwards
Mrs. LeBaron Willard	Mrs. Chester Brown
Miss Grace Stephens	Mrs. Norman Dahl
Mrs. Robert Wilson, Jr.	Miss Elizabeth Edwards

ICE CREAM BOOTH
Miss Irene Gay, *Chairman*

Mrs. Harry Ease	Mrs. Samuel Joyce
Mrs. George W. Slyer	Miss Angelique Osborne
Mrs. Robert Hamlin	

HOT DOG BOOTH
Mrs. E. Lynch, *Chairman*

Mrs. John Herrin	Mr. Richard Steele, Jr.
Mrs. Maurice Trainer	Mr. Dick Strong
Mr. Carlie Potter	Mr. Edward Tillinghast
Mr. Robert Lynch, Jr.	Mr. Joseph Cangliosi
Mr. Newton Tiffany	Mr. Robert Lynch

also
thru courtesy of Mr. D. Roberts
Mr. and Mrs. Harrington

RUMMAGE
Mrs. R. Draper Richards, *Chairman*

Mrs. Francis Kennedy	Mrs. Kaauss
Mrs. M. Eass	Mrs. Alston Park

SCARVES BOOTH
Mrs. John Cole, *Chairman*

Mrs. Grant Harkness	Mr. William Burton
Mrs. John Olin	Mr. George Rentschler
Mrs. Alexander Brooke	Mr. A. Cuthbert Potter
Mrs. Knight Wooley	Mrs. Bianci
Mrs. Leisdorf	

THE POST OFFICE
Mrs. Edward E. Bartlett, Jr., *Chairman*

Mrs. E. H. Sitet	Mrs. Newell Ward
Mrs. Charles Klotz	Mrs. Thomas Kelland
Mrs. Anne Wright	Mrs. George Helm
Mrs. George McClellan	Mrs. Julian Myrick
Mrs. Alexander Fraser	Mrs. Ledyard Mitchell
Mrs. Louis Dawdney	Mrs. Irving Snow
Mrs. Frederick Ryan	Mrs. William Claiborne Hall
Mrs. Earle Sinclair	Mrs. William Morgan
Mrs. Irvine Brooks	

The program for the 54th annual fair sponsored by the Ladies Village Improvement Society at the Mulford farm July 29, 1949, listed events and committee members. Events that were held from 1 p.m. to 6 p.m. included booths selling aprons, balloons, cakes, candy, cigarettes, flowers, ice cream, hot dogs, and scarves. A country dance was held at 8 p.m. (Ladies Village Improvement Society.)

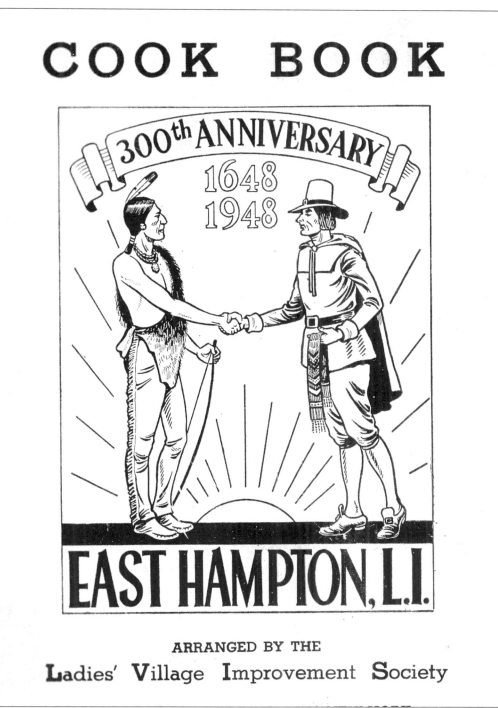

COOK BOOK

300th ANNIVERSARY
1648
1948

EAST HAMPTON, L.I.

ARRANGED BY THE

Ladies' Village Improvement Society

Shown is the cover of the cookbook compiled by the Ladies Village Improvement Society in 1948. The group has published cookbooks regularly since the turn of the century. This one, issued on the 300th anniversary of the village, contained members' recipes, many of which had been passed down from generation to generation, plus those of area residents. (Ladies Village Improvement Society.)

Five

THE SUMMER COLONY
THE ESTATE SECTION

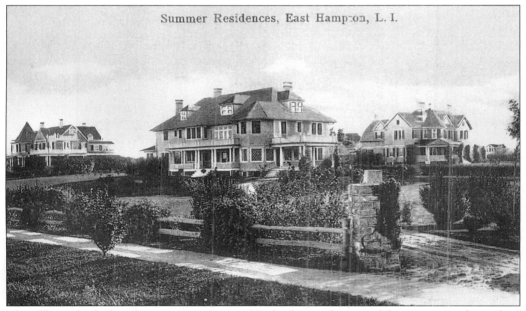

Summer Residences, East Hampton, L. I.

The affluent built their homes, most designed by leading architects of the era, on roads south of the highway with names such as Lily Pond Lane, Apacuoque Road, Ocean Avenue, West End Avenue, and Lee Avenue. Many overlooked Hook Pond; others were on the dunes. All were landscaped to perfection with notable gardens. This picture shows the house at One Lily Pond Lane and the bordering homes. (Harvey Ginsberg postcard collection.)

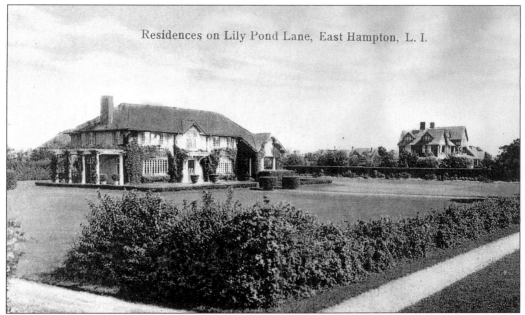

Designed by Harrie T. Lindeberg for Edward T. Cockcroft in 1905, this house at 88 Lily Pond Lane was well publicized at the time, appearing on the cover of *House and Garden*. For 60 years (1936–1996), it was the home of Franklin and Winifred Lee d'Olier, an aunt of Jacqueline Kennedy Onassis. (Harvey Ginsberg postcard collection.)

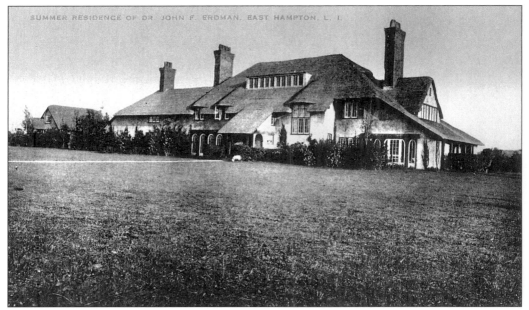

Coxwould was designed by Harrie T. Lindeberg in 1913 for Dr. John E. Erdmann, a prominent New York surgeon who lived in it until 1954. Patterned after the Coxwould cottages of England, it is one of four homes the firm of Albro & Lindeberg designed on Lily Pond Lane. The cottage is at 89 Lily Pond Lane. The shingles were laid to suggest a thatched roof. (Harvey Ginsberg postcard collection.)

Pictured at 53 Lily Pond Lane is one of three houses built by Frederick K. Hollister, a physician and lecturer at New York Medical College. A fourth, built as a rental house on Drew Lane, was designed by John Custis Lawrence. In 1975, it was moved back from the ocean. (East Hampton Historical Society.)

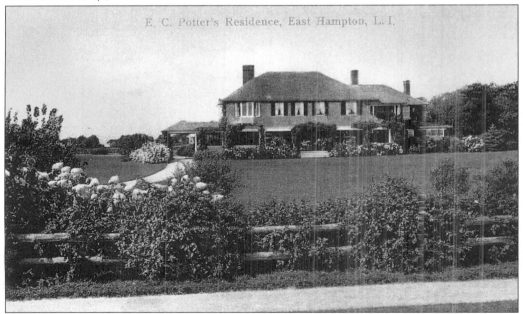

This house, designed by Joseph Greenleaf Thorp, was built for E. Clifford Potter, who developed Park Avenue in New York. Potter bought the lot at the corner of Ocean Avenue and Lily Pond Lane at a court-ordered auction of the estate of Dan Talmage's Sons Company in 1898. In all, 31 building sites on Ocean, Lee, and Cottage Avenues and Lily Pond Lane were auctioned. The house was illustrated in Charles deKay's *Summer Homes of East Hampton*. (Harvey Ginsberg postcard collection.)

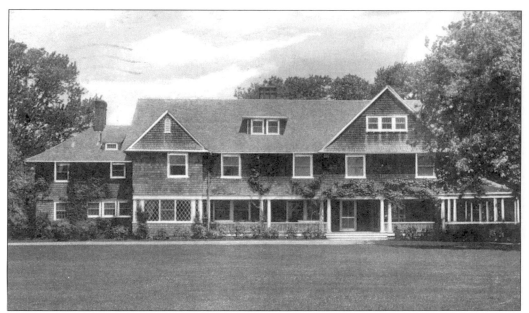

Built at the turn of the century for Harkness Edwards at 18 Lee Avenue, this three-story shingle-style house was surrounded on two sides by a wide, partially enclosed porch. A noted sailor, Edwards owned the 70-foot yacht *Wakiya*, with which he won the 6th annual Miami-to-Nassau sailboat race in 1939, defeating 80 entries. (Author's archives.)

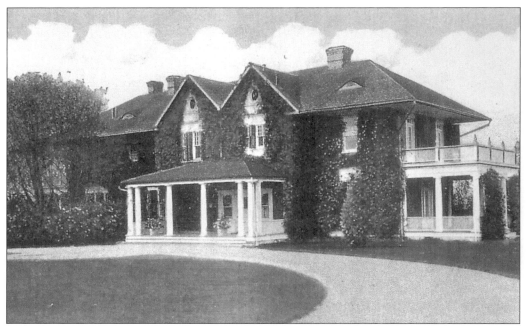

John Drew, who was the "dean of the American stage" for 54 years and the head of the legendary Barrymore theatrical family, built this house at the corner of Drew and Lily Pond Lanes in 1900. It was designed by James Brown. Drew spent every summer in it until his death in 1927. The house has been razed. (Harvey Ginsberg postcard collection.)

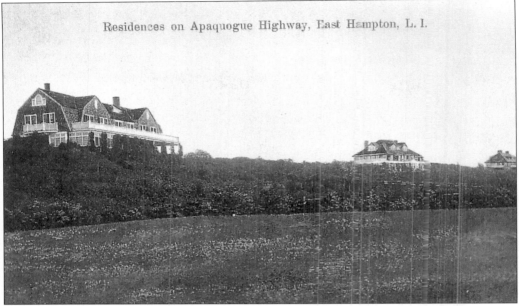

Residences on Apaquogue Highway, East Hampton, L. I.

Larger than many of the residences in the estate section, those on Apaquogue Road were built high on the second dune to catch the breeze and views of the ocean. Many have been razed. (Harvey Ginsberg postcard collection.)

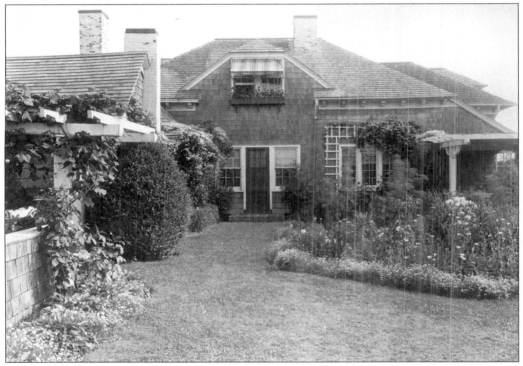

Bayberry, a shingle-style two-story house, was built by John Nelson Cole on Apaquogue Road in 1927. It was his home for 35 years. He was the winner of many singles and doubles tennis trophies at the Maidstone Club in 1924, 1926, 1932, and 1934 (Nassau County Museum Long Island Studies Institute.)

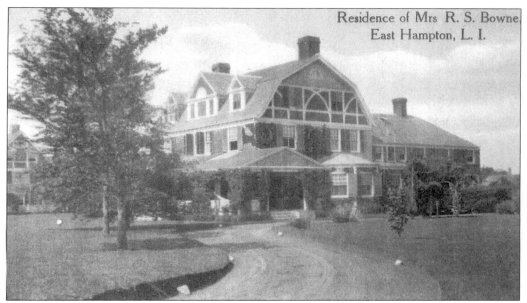

Robert Southgate Bowne, the first president of the Long Island Railroad and a founder of the Maidstone Club, purchased two-acres on Ocean Avenue in 1889 and built a summer cottage there. The three-story shingle-style house has a wide front porch. (Harvey Ginsberg postcard collection.)

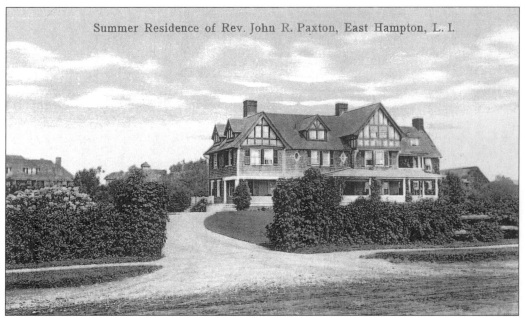

Joseph Greenleaf Thorp designed this 86 Lily Pond Lane cottage for Rev. John R. Paxton, one of the colony of clergymen on Divinity Hill, in 1901. The pastor of New York's West Presbyterian Church, he first came to East Hampton in 1892, renting a house on Cottage Avenue. In 1906, an addition was added to the Lily Pond Lane house and in 1923, extensive alterations were made. (Harvey Ginsberg postcard collection.)

This shingle-style house on Lee Avenue and Crossways was designed in 1898 for Schuyler Quackenbush by Mrs. Quackenbush's brother, Cyrus L.W. Eidlitz, who lived across the street. It later was purchased by Dr. O.M. Edwards. Today, it stands nearly untouched and presents one of the best images of a turn-of-the-century shingled house. (East Hampton Historical Society)

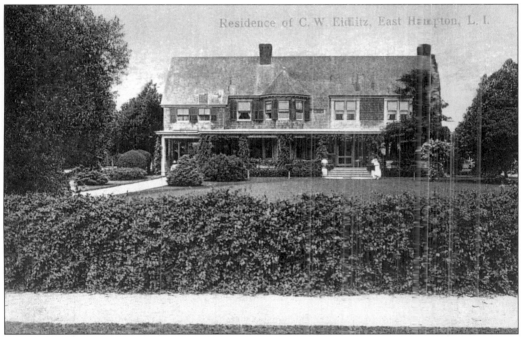

Cyrus L.W. Eidlitz, who designed the New York Times Building, designed Overlea, a shingle-style cottage at 58 Ocean Avenue, for his own use in 1897. In 1898, he added an extension on the front veranda. Three years later, he built a second story on the west end of the house. It was one of two houses he designed in East Hampton. The other was for his sister, Mrs. Schuyler Quackenbush, across the street. (Harvey Ginsberg postcard collection.)

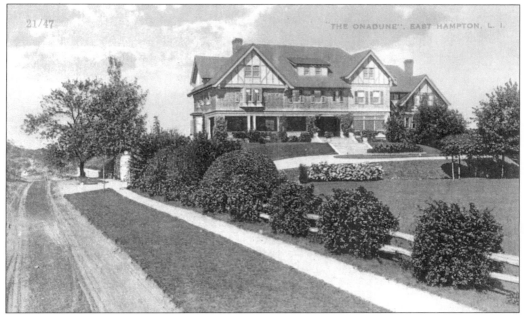

Built in 1903 on the inner dune off Georgica Road, the three-story shingle-style house designed by John Custis Lawrence was the fourth house built for Mrs. S. Fisher Johnson. The other three houses, all of them in the shingle style and with gambrel roofs, were designed by Joseph Greenleaf Thorp. This house at the corner of Georgica Road and Crossways was meticulously restored in the early 1990s. (Harvey Ginsberg postcard collection.)

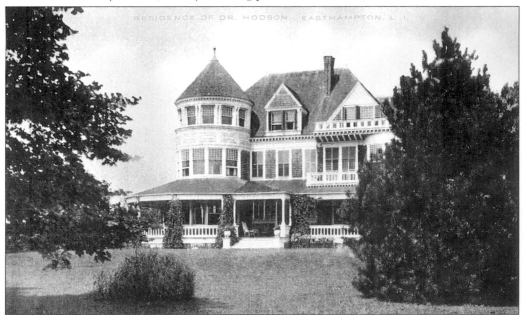

This Queen Anne-style three-story frame house was built for New York State senator Charles S. Adams at 30 Lee Avenue in 1891. A showplace for many years, it was designed by William B. Tuthill, the architect of Carnegie Hall. It was renovated in 1930 by Aymar Embury II. Today, it sits nearly empty in an overgrown park. It is one of the largest surviving houses in the village today. (Harvey Ginsberg postcard collection.)

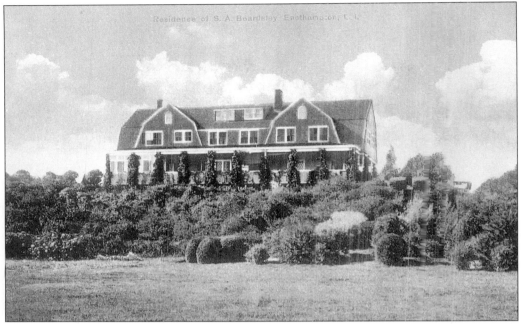

Built in 1899 for S.A. Beardsley on the inner dune off Lee Avenue, this three-story shingle-style house was designed by William Strom, a New York architect. Commanding a view of the summer colony and Atlantic Ocean, it was surrounded by evergreens. It has been razed. (Harvey Ginsberg postcard collection.)

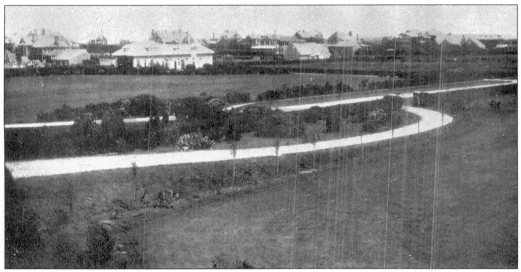

Pictured is the driveway to the S.A. Beardsley house, built on the inner dune off Lee Avenue in 1899. In the background are the carriage houses for properties on Cottage Avenue. (Harvey Ginsberg postcard collection.)

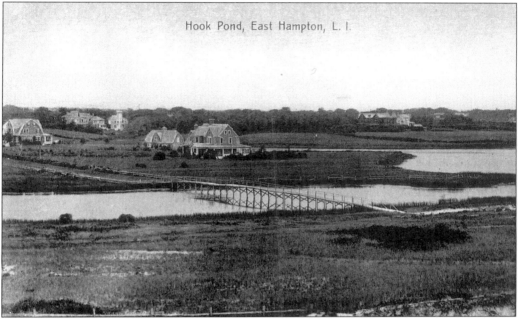

A footpath leads to a bridge that crosses Hook Pond and leads to the dunes and the ocean beaches. In the background are early shingle-style houses that were built around the freshwater pond fed by runoff and streams. Nearest to the water is the home of Mrs. E.A. Blakeman of New York, built in 1891 on Terbell Lane. (Harvey Ginsberg postcard collection.)

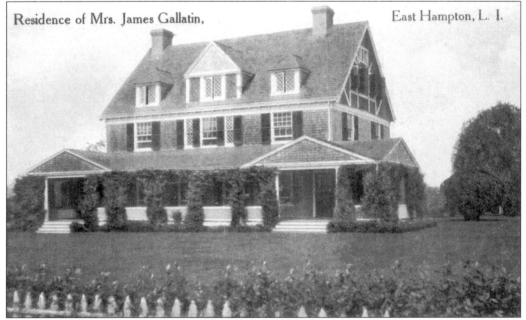

Built on a two-acre tract on Ocean Avenue in 1889, the James Gallatin house is a three-story shingle-style residence. The founder and first president of the Association for Improving the Condition of the Poor in New York, he had summered in East Hampton since he was a boy. In 1890, he had an experimental laboratory built onto the cottage. (Harvey Ginsberg postcard collection.)

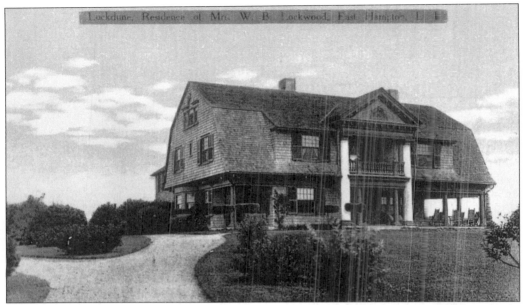

Lockwood Villa, built c. 1900 between Ocean Avenue and Terbell Lane, was a three-story shingle-style residence combining a gambrel roof with a pediment supported by two Doric columns. The main entrance overlooked the lower end of Hook Pond. The house has been razed, although a two-story carriage house remains. (Harvey Ginsberg postcard collection.)

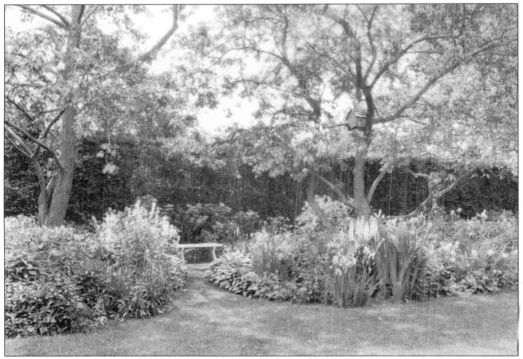

Small in scale compared to many other East Hampton gardens, those at Lockwood Villa compressed a multitude of different flowers and shrubs into a small space surrounded by a lawn. In the background is a marble bench against a privet hedge. (Nassau County Museum Long Island Studies Institute.)

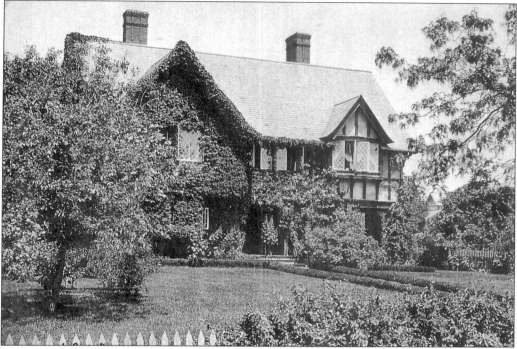

The premier resident architect of East Hampton, Joseph Greenleaf Thorp, designed this Elizabethan-style house at 12 Woods Lane for himself in 1893. He was responsible for much of the architecture in the summer colony. In 1912, five years after this photograph was taken, he sold the house and moved to Italy with his mother and sister. (East Hampton Library.)

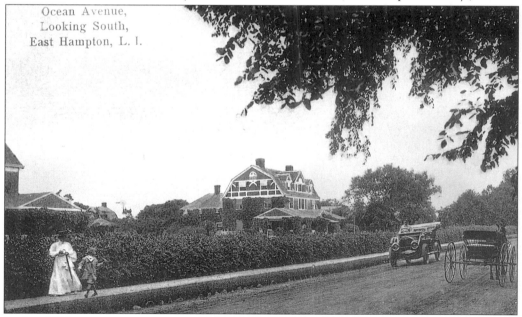

In this 1907 image, a vintage car and horse-drawn carriage pass on Ocean Avenue, called by some "the road to the beach." From Ocean Avenue, Terbell Lane branched south to Hook Pond. Pictured are the Gallatin and Bowne residences. (Harvey Ginsberg postcard collection.)

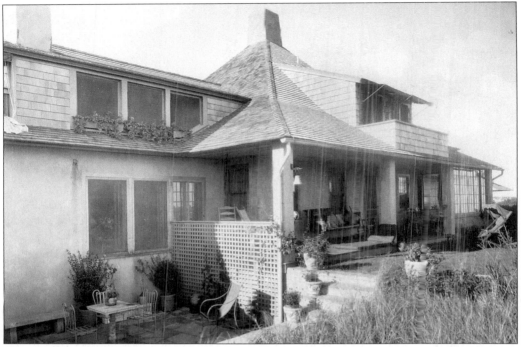

The Ink Pot, the summer cottage of sculptress Maud Sherwood Jewett, was on the dunes on Apaquogue Road, overlooking the ocean. When the Jewetts bought the house in 1912 and added an addition, it became a gathering place for local artists. She designed many bronze and plaster statuettes for her house and garden. (Nassau County Museum Long Island Studies Institute.)

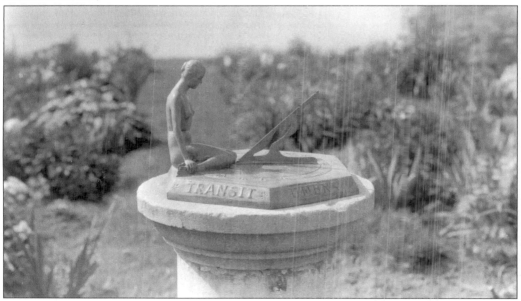

The bronze statue of a nude woman rests on the edge of a sundial designed by Mrs. Jewett for her garden. She not only gained renown for her sundials, fountains, and statues, but also for the WWI monument East Hampton erected beside the Hook Mill. (Nassau County Museum Long Island Studies Institute.)

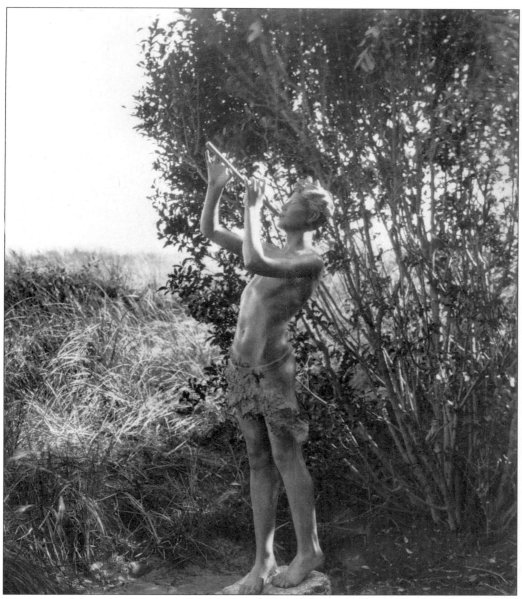

The bronze figure entitled *Piping Pan* was cast by Maud Sherwood Jewett as a statuette for her garden. It sat near a sundial, fountains, and the figure of a young Native American girl entitled *Voice of the Water Spirit.* (Nassau County Museum Long Island Studies Institute.)

Designed by Lewis Colt Albro, the Hamilton King house on Apaquogue Road was originally two fishermen's cottages when King, a painter, bought the property in 1921. He joined the two buildings with a long living room. The exterior surfaces are grey stucco. (Nassau County Museum Long Island Studies Institute.)

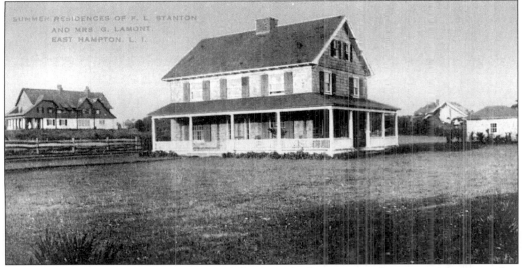

The F.L. Stanton house on Georgica Road (left) was built in 1916 and extensively renovated in 1928 by Alfred Bell. He added 12-foot extensions on each side and a 4-foot addition in the front that was designed by John Custis Lawrence. The George Lamont house on Cottage Avenue was built in 1912 and has since had its porches removed. (Harvey Ginsberg postcard collection.)

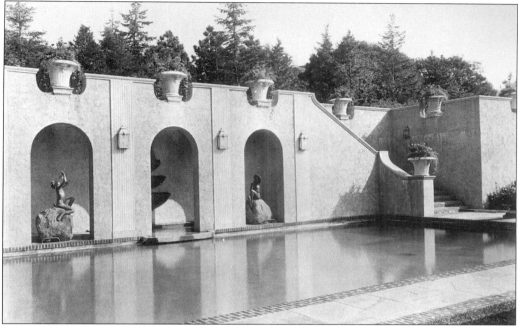

This Hollywood-style pool, part of a large estate that was once entered through brick posts on Georgica Road and Crossways, survives today as part of a new estate with an entrance on Darby Lane. The original main house, owned later by Phyliss Newman and Adolph Green, burned in August 1969 during the outdoor wedding of her niece. A caterer's leaky gas tank was blamed. The pool, built into a hillside below the original house, has been restored. (Nassau County Museum Long Island Studies Institute.)

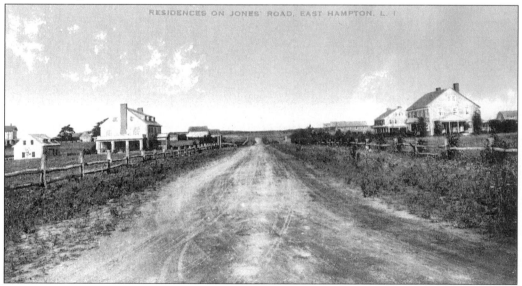

Connecting Apaquogue Road and Lily Pond Lane, the block-long Jones Road overlooks the dunes and the Atlantic Ocean. Bordered by split rail fences, a carryover from when the area was farmland, the treeless dirt road was flanked by two- and three-story houses when this image was taken c. 1910. Except for the mature trees, the street looks exactly the same today. (Harvey Ginsberg postcard collection.)

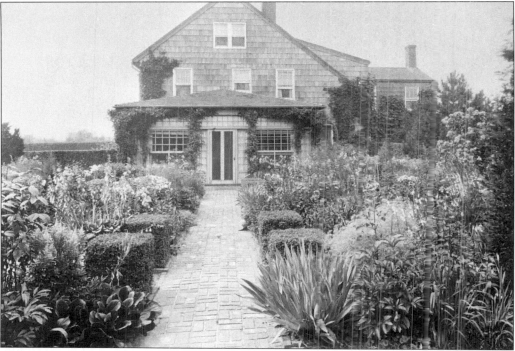

Miss Mary Lansing Pruyn, a New York artist and art connoisseur, and her sister, Neltje Knickerbocker Pruyn, owned a summer house on Jones Road for many years. Mary was noted for her many canvasses of flowers, her favorite art subject. (Nassau County Museum Long Island Studies Institute.)

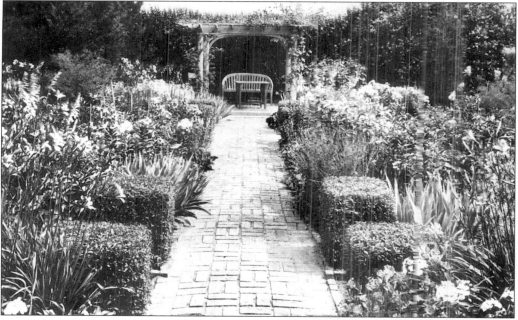

Pictured is a brick walk bordered by blooming flowers and trimmed shrubs at the Pruyn sisters house on Jones Road. In the background is a rose-covered trellis with a bench and table beneath it. (Nassau County Museum Long Island Studies Institute.)

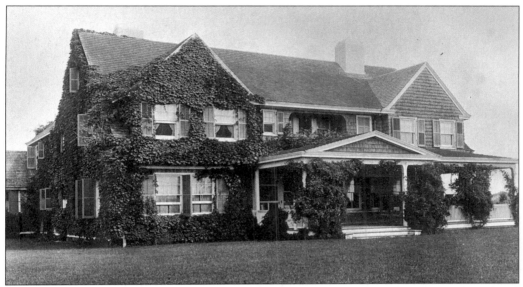

Designed by Joseph Greenleaf Thorp in 1897, this house on the corner of Lily Pond Lane and West End Road was built for Mrs. F. Stanhope Phillips, the daughter of the first editor of the *Detroit Free Press*. Subsequent owners included Robert Carmen Hill and Edith Bouvier Beale. Known as Grey Gardens, it was the topic of the 1976 film depicting the eccentric and reclusive lives of the aunt and cousin of Jacqueline Kennedy Onassis. (Nassau County Museum Long Island Studies Institute.)

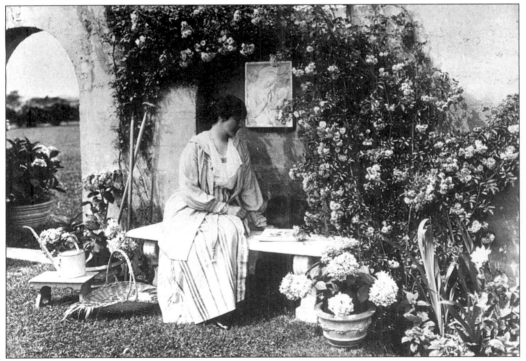

Mrs. Robert Carmen Hill, an avid gardner, purchased the F. Stanhope Phillips house on West End Road in 1913. She sits on a marble bench beneath a blooming rose trellis in the walled garden on the estate in 1923. (Nassau County Museum Long Island Studies Institute.)

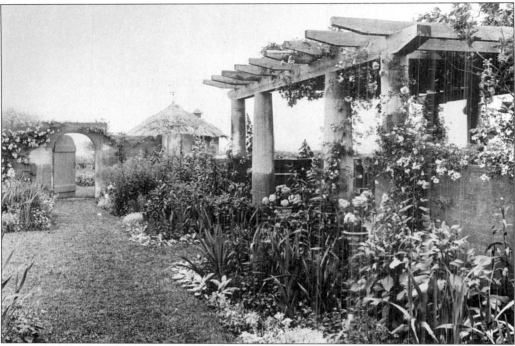

Mrs. Hill created a nationally known garden on her estate, Grey Gardens, on West End Road. This 1923 image shows a rose-covered arbor at one side of the garden, a grass pathway bordered by flowers, and a gate leading to the garden house. Today, the gardens have been restored and look much as they did in this photograph. (Nassau County Museum Long Island Studies Institute.)

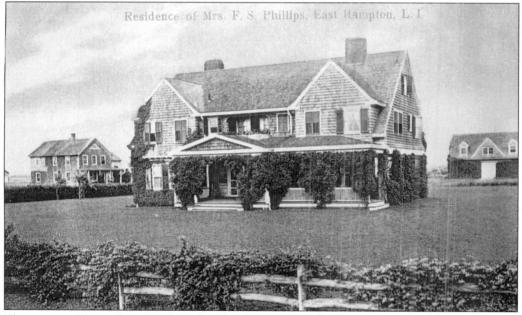

This picture shows Grey Gardens shortly after it was built in 1897 and before the extensive gardens that gained it national recognition were added by the Hills. In this image, the carriage house is seen in the rear of the property. (Harvey Ginsberg postcard collection.)

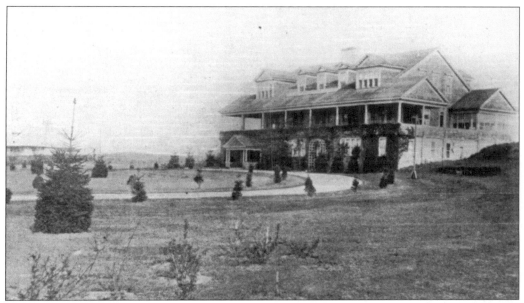

Evesdune, the Judge Everett Edward McCall villa on West End Road, had its principal rooms and verandas on the second floor to provide a view of the ocean and Georgica Pond. It was built for Judge McCall in 1916. When the McCall house burned in 1927, Nathaniel A. Campbell built a Tudor-style stucco and timber house on the site. It was razed in 1995 for a new house. (East Hampton Historical Society.)

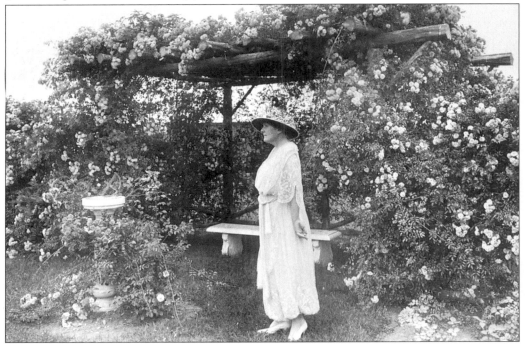

Mrs. Everett McCall stands beside a rose-covered trellis, sheltering a marble bench in the extensive gardens at Evesdune, c. 1920. Protected from the ocean by the dunes, the gardens were set against a backdrop of evergreens. (Nassau County Museum Long Island Studies Institute.)

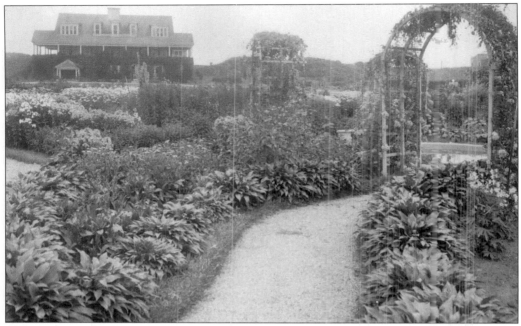

The gardens at Evesdune stretched from West End Road to the dunes. Bisected by meandering pathways, each with a trellis covered with a different species of rose, the gardens were filled with every type of flower, ensuring continuous bloom from spring to fall. (Nassau County Museum Long Island Studies Institute.)

This 1928 image shows the gardens at Crossways, the William Wallace Benjamin house that was built in 1902. The gardens, designed by early landscape designer Marian C. Coffin, featured rigidly edged pools, carefully shaped hedges, and well-placed sculptures. The three-story shingle-style house was designed by George A. Eldredge and John Custis Lawrence. (Nassau County Museum Long Island Studies Institute.)

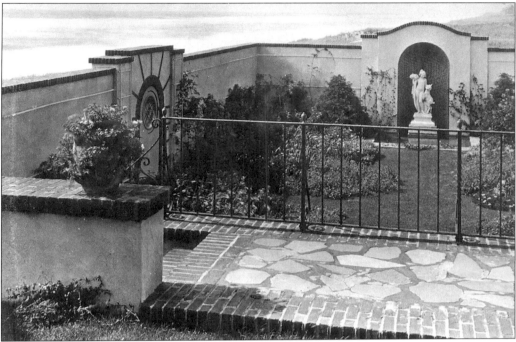

Gullcrest, built for Carroll Wainwright on West End Road in 1928, was designed by Penrose V. Stout. The large, shingled, hipped-roof house atop the dunes has two wings centered on a stylized portico. It is approached by a curving driveway bordered by gardens and lawns. Pictured is the garden overlooking the ocean. The house and grounds are now undergoing an extensive renovation. (Nassau County Museum Long Island Studies Institute.)

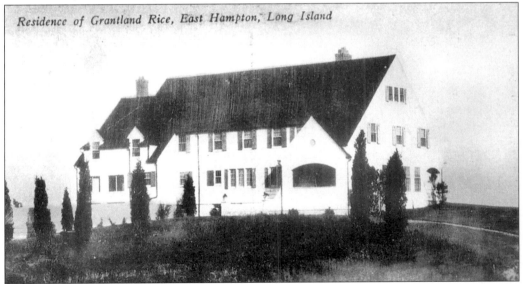

Residence of Grantland Rice, East Hampton, Long Island

John Custis Lawrence designed this three-story house on West End Road in 1927 for the famous sportswriter Grantland Rice. Rice's close friend, Ring Lardner, the famous short story writer, built a two-story shingle-style house next door. Both houses were severely damaged in the 1931 hurricane and were moved back from the beach at that time. (Harvey Ginsberg postcard collection.)

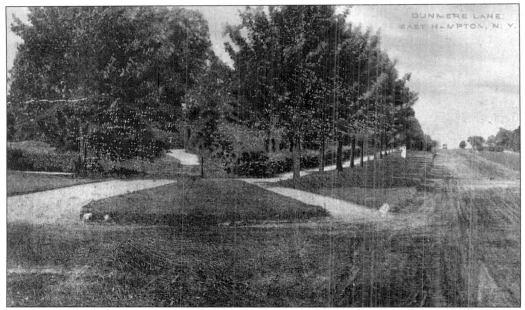

Pictured is the intersection of Dunemere Lane, stretching south toward Hook Pond, and Main Street at the turn of the 19th century. The corner today is the site of Guild Hall. To the left on Main Street is a historical marker at the site of one of East Hampton's first churches, built in 1717, where Dr. Samuel Buell preached. (Harvey Ginsberg postcard collection.)

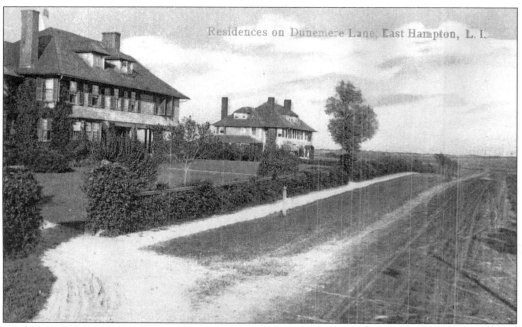

Stretching south from Main Street toward the beach, Dunemere Lane is lined with expensive, large shingle-style houses. When this image was taken, c. 1910, it was still a dirt road and had not yet been extended to Egypt and Further Lanes. (Harvey Ginsberg postcard collection.)

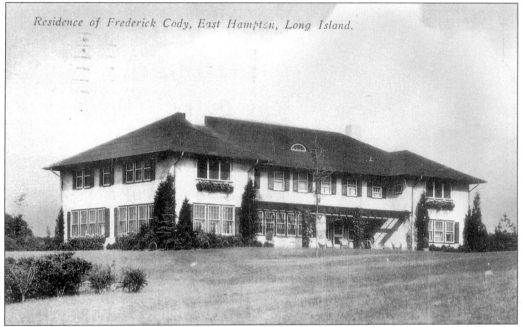

Residence of Frederick Cody, East Hampton, Long Island.

Fairways, the Frederick Cody house at 18 Further Lane, overlooked the golf course, Hook Pond, the ocean, and the village. It was designed by John Custis Lawrence in 1928. The twenty-room, two-story house was built on a four-acre tract. Cody was vice president of the McCann Erikson Inc. advertising agency in New York. (Harvey Ginsberg postcard collection.)

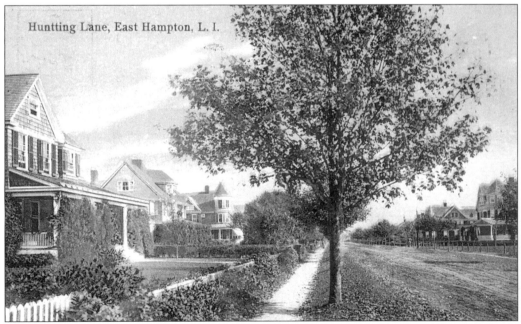

Huntting Lane, East Hampton, L. I.

Huntting Lane looks toward Egypt Lane in this photograph taken at the turn of the 19th century. To the right is the Huntting Inn, built originally as a house for Rev. Nathaniel Huntting, East Hampton's second minister. (Author's archives.)

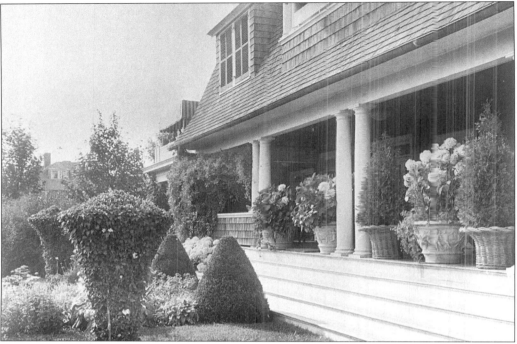

The front porch of the Fens was sheltered by a gambrel roof that was supported by Doric columns. Designed by Joseph Greenleaf Thorp for Lorenzo E. Woodhouse on Huntting Lane in 1904, the 12,000-square-foot residence was extended in size in 1908 by additional rooms and a porte-cochère. It was razed in 1948. (Nassau County Museum Long Island Studies Institute.)

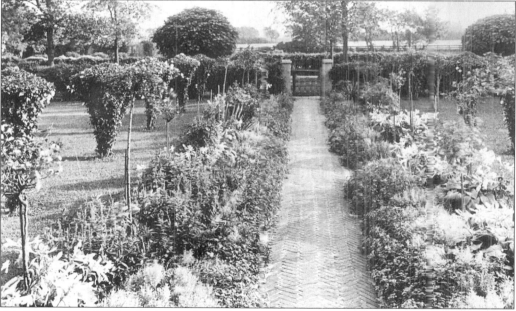

A brick sidewalk laid in the herringbone design at the Lorenzo E. Woodhouse estate, the Fens, leads to a gate and Huntting Lane. It is bordered by blooming flowers and rows of shrubs trimmed in fancy designs in this 1924 picture. Only the gateposts survive today. (Nassau County Museum Long Island Studies Institute.)

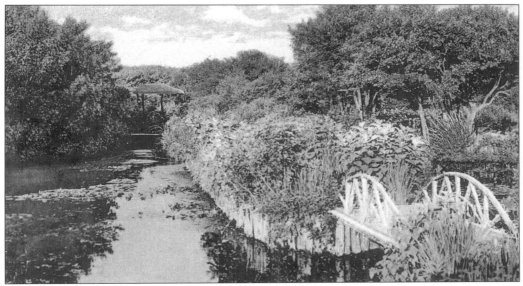

The gardens were part of the extensive Woodhouse estate. The sides of the flower beds were supported by wooden slats to keep the dirt from washing away. The four-acre Japanese gardens were reached by arched bridges and walkways bordered by iris, hostas, lily ponds, and swamp maple trees, the signature tree of the gardens. (Harvey GInsberg postcard collection.)

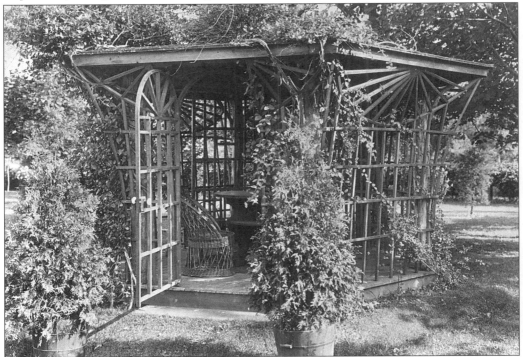

Pictured is a vine-covered bamboo tea house in the Japanese water gardens at Greycroft. After Mrs. Woodhouse's death in 1908, her second husband, Stephen S. Cummings, continued the tradition of opening the gardens to the public through the 1920s. In 1935, they were inherited by Mary Woodhouse, who gave them and Greycroft to the Leighton Rollins School of Acting in 1937. (Nassau County Museum Long Island Studies Institute.)

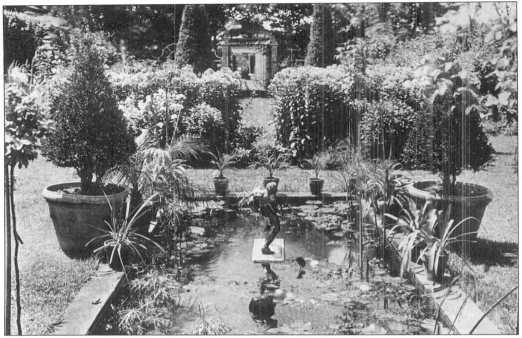

A bronze nymph overlooks a lily pond surrounded by potted plants and shrubs on the lawn of the Lorenzo E. Woodhouse estate. Nearby are numerous flowering shrubs and, in the background, a brick path leading to a trellised vine-covered walkway. (Nassau County Museum Long Island Studies Institute.)

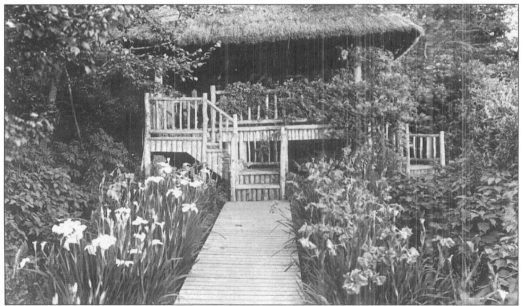

A wooden walkway bordered by thousands of iris, many imported from Japan, leads to the steps of this thatched-roof pavilion. The pavilion overlooks the Woodhouse Japanese water gardens, the earliest adaptation of such gardens in this country. A more secluded octagonal pavilion was on the southern boundary of the gardens. (Nassau County Museum Long Island Studies Institute.)

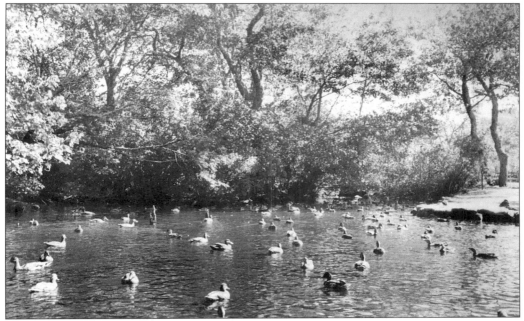

The nature trail and Japanese water gardens were donated to the Village of East Hampton in 1951 by Mary Woodhouse. Annually, thousands of children feed the mallard ducks that swim in the stream that bisects the gardens. The adjacent nature trails were started in 1936 when Mary Woodhouse loaned the land to the Garden Club of East Hampton. (Author's archives.)

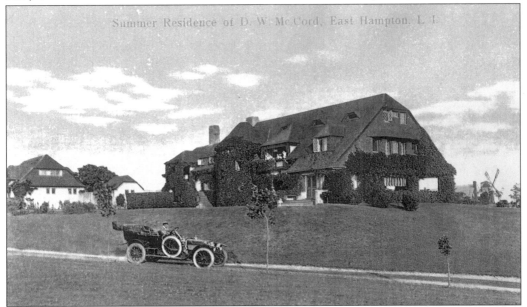

This house was designed for C.C. Rice by Grosvenor Atterbury in 1899 and later owned by D.W. McCord. It stood on Hither Lane and commanded an uninterrupted view of the Eastern Plain and Hook Pond. It burned in a fire caused by a tossed cigarette in 1920. Evan Frankel bought the property in 1946, renovating the carriage house and sinking a swimming pool into the foundation of the earlier house. He called it Brigadoon. It was his home until his death in 1991. (Harvey Ginsberg postcard collection.)

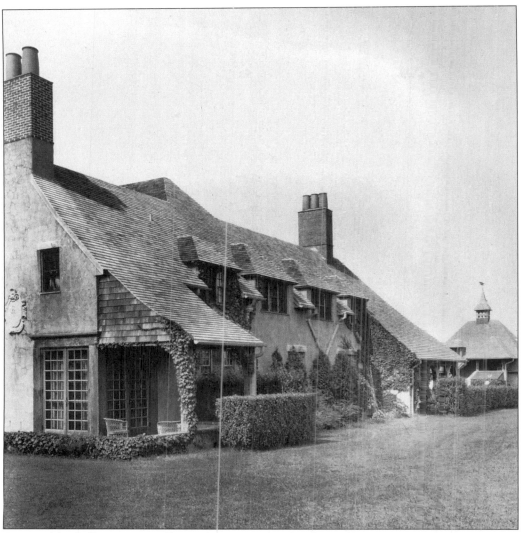

Designed by Polhemus & Coffin in the Jacobean style, the William S. Jenney house was built on Egypt Lane in 1917. Sheathed in stucco, the fourteen-room, two-story house is approached by a curving driveway. Its towering chimneys overlook two porches, extensive gardens, and a rear terrace with a pool in its center. The carriage house has been razed. (Nassau County Museum Long Island Studies Institute.)

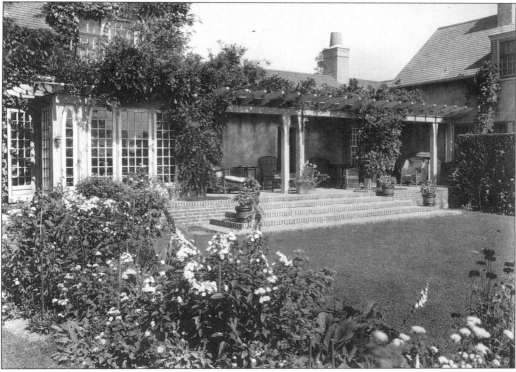

Extensive gardens and arbors covered with vines and roses fill the rear of the William S. Jenney house. On steps leading to the rear patio, urns filled with different species of flowers abound. (Nassau County Museum Long Island Studies Institute.)

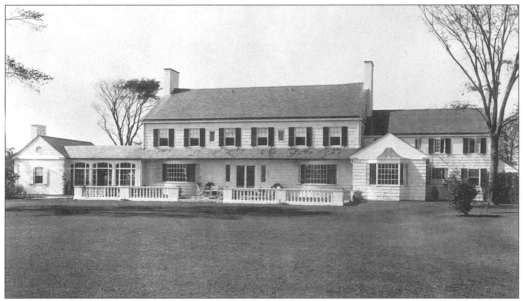

Designed for George Hewitt Roberts by Aymar Embury II in 1930, Furtherfield is a two-story, clapboard, Colonial-style house on a site stretching between Further and Middle Lanes. The property includes a carriage house and extensive lawns. (Nassau County Museum Long Island Studies Institute.)

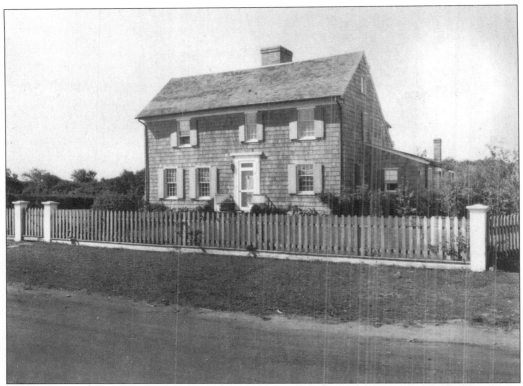

Originally located on Main Street and Davids Lane, the two-story boardinghouse, known in the 1890s as Rowdy Hall, was the center of the summer art colony. Every morning, artists fanned into nearby fields to set up their easels. Later, they returned to the boardinghouse, where their noise over beer and cards earned the place it name. It was later moved to the corner of Egypt and Davids Lanes. (Nassau County Museum Long Island Studies Institute.)

Pictured is the fireplace in Rowdy Hall. Mr. and Mrs. Jack Bouvier brought their daughter, Jacqueline, to this house after her birth at Southampton Hospital. The Bouviers were wed on July 7, 1928 at St. Philomena's church. Jacqueline spent her childhood summers here. (Nassau County Museum Long Island Studies Institute.)

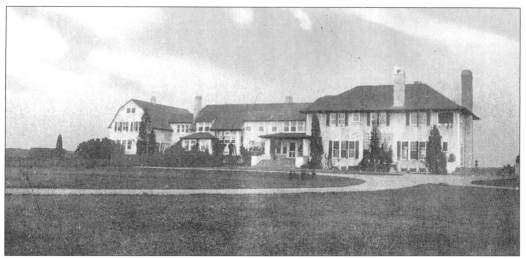

The Dunes, the 30-room stucco F.B. Wiborg family mansion, was the center of an 80-acre estate to the west of the present Maidstone Club. Designed by Grosvenor Atterbury in 1895, the property included Italian gardens, terraces, a dairy, stables, and a garage complex. The house was intentionally burned in July 1941, when the Murphys were unable to sell it, rent it, or continue to pay for its maintenance and taxes. (Harvey Ginsberg postcard collection.)

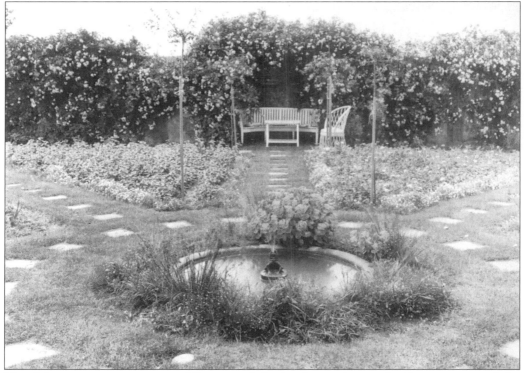

Noted for its numerous species of flowers and shrubs, the gardens at the Dunes commanded a view of both the ocean and village. The estate was later the home of Wiborg's daughter, Sara, and her husband, Gerald Murphy, who renovated the carriage house on the shore of Hook Pond and renamed it Swan Cove. (Nassau County Museum Long Island Studies Institute.)

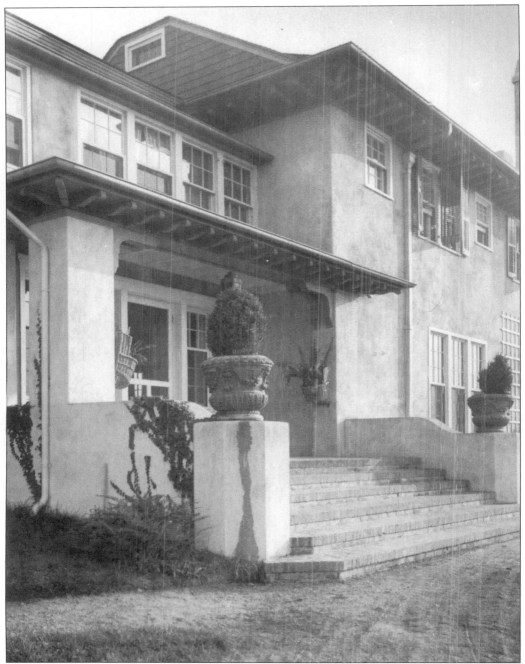

Located at the end of a long curving driveway that bisected lawns, gardens, and shrubs, the main entrance to the Dunes was impressive. The house, known to many as the Pink House because of the color of its stucco and roof, was the center of an estate comprising all the properties on and off Highway Behind the Pond. (Nassau County Museum Long Island Studies Institute.)

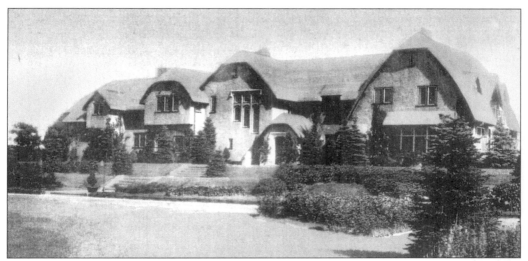

Nid de Pappilon was built in 1918 on Old Beach Lane for Robert Appleton, president of the Appleton Publishing Company. The Elizabethan-style villa, then the most fanciful house in East Hampton, was designed by Frank E. Newman. Appleton expanded his dune holdings in 1919 to 100-acres with a beach frontage of 1,500 feet and added a polo field and paddock. (Harvey Ginsberg postcard collection.)

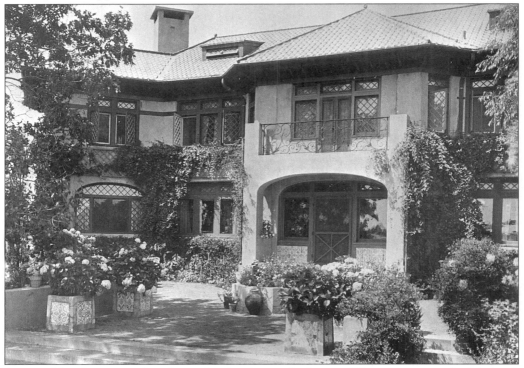

Designed by Grosvenor Atterbury, the Creeks was built on a 75-acre tract on the Montauk Highway in 1898 for Albert Herter and his wife, Adele. Both were artists. In 1899, stables were added and, in 1910, a studio. In 1951, their son, Christian, a U.S. Secretary of State, sold it to Alfonso Ossorio, whose sculptures decorate the grounds. (Nassau County Museum Long Island Studies Institute.)

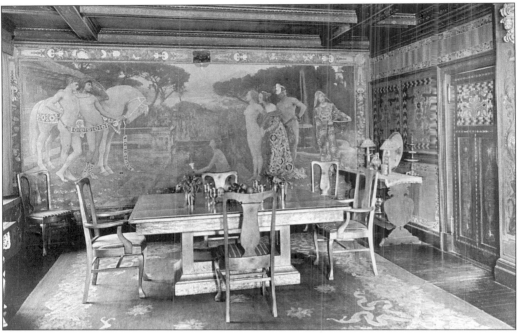

A free interpretation of an Italian villa, the U-shaped Herter residence occupies one of the prize building sites on Georgica Pond. It was sold to Ronald Perelman in the 1990s, who extensively remodeled it in three months. Pictured is a wall-sized mural in the original dining room. (Nassau County Museum Long Island Studies Institute.)

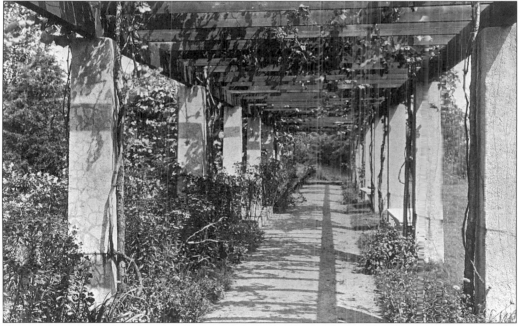

Herter designed the gardens in close proximity to the residence. For the entrance court, he planned the "Garden of the Sun" with yellow and pink flowers. On the Georgica Pond side, he placed a terrace called the "Garden of the Moon" with white and blue flowers. (Nassau County Museum Long Island Studies Institute.)

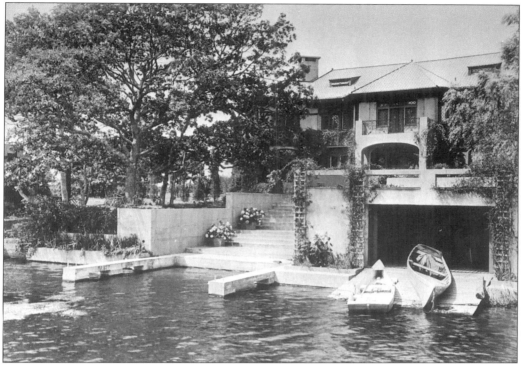

Shown is the Herter boathouse, c. 1921, on Georgica Pond. A section of the house and the Italian gardens can also be seen. The Italian theme of the house was carried into the design of the boathouse and studios. It has unobstructed views of Georgica Pond and the ocean just beyond. (Nassau County Museum Long Island Studies Institute.)

Henry A. James, a lawyer, built a rambling shingle-and-brick house on the dunes between the ocean and Georgica Pond in 1891. He spent every summer in East Hampton from 1891 to 1929. Considered one of East Hampton's pioneer summer colonists, he served as a director of the Maidstone Club from 1918 to 1921. (Harvey Ginsberg postcard collection.)

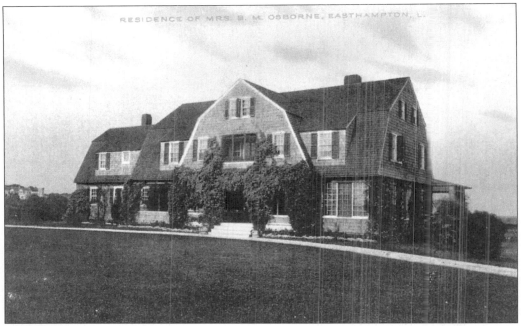

John Custis Lawrence designed the house of Mrs. B.M. Osborne on Terbell Lane in 1904. The rambling three-story, shingle-style residence overlooks Hook Pond. (Harvey Ginsberg postcard collection.)

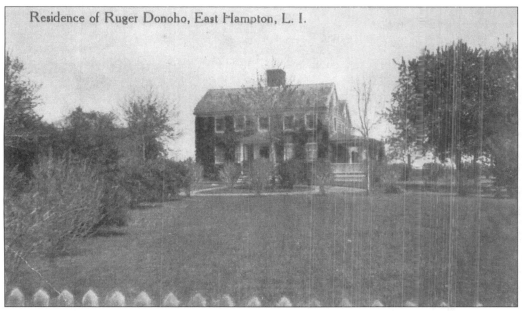

Residence of Ruger Donoho, East Hampton, L. I.

Ruger Donoho, an artist, bought property in 1894 on Egypt Lane at the foot of Fithian fields and built a two-story, shingle-style house. He tried to buy the meadow across the road from his house, but Jonathan Fithian refused to sell because he pastured his cow there. Donoho and his neighbor, Childe Hassam, painted scenes in the Fithian fields. (Harvey Ginsberg postcard collection.)

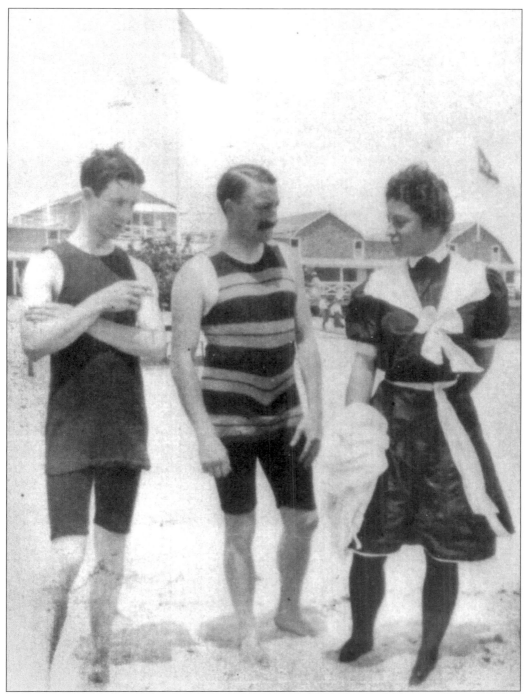

Pictured in 1910 is John Drew (center) in front of Culver's Bathing Pavilion on Main Beach with Jack Gallatin and Miss Gladys Robertson. The men are clad from neck to knees and Miss Robinson from neck to toe. (East Hampton Library.)

Six

BEACH, CLUBS, AND HOTELS

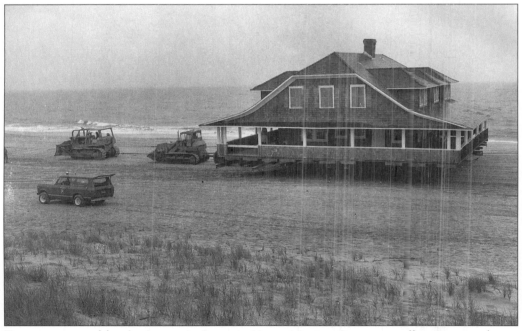

Tractors operated by the James A. Brownie House Moving Company pull a two-story house along the beach from Bridgehampton toward Wainscott on June 13, 1975. The house is supported on beams mounted on wheels. Attributed to Stanford White, the house had been acquired by James Tree. It burned one year after being set on its new foundation. (Ron Ziel archives.)

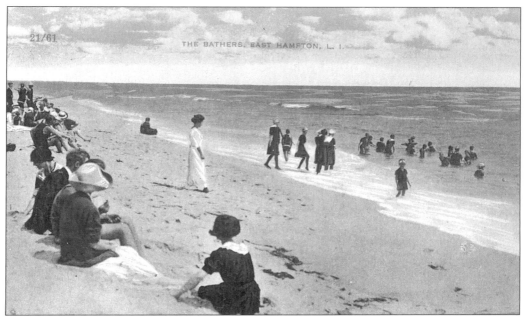

THE BATHERS, EAST HAMPTON, L. I.

Sitting on a three- to four-foot-high sand bluff carved by the waves at high tide, visitors to Main Beach watch bathers venture into the ocean at low tide in this image taken at the turn of the century. (Author's archives.)

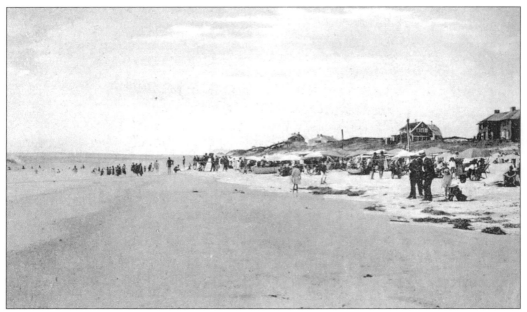

Taken at low tide in the 1920s, this image shows a crowded beach and bathers in the ocean west of Culver's Bathing Pavilion. Most of the people on the beach are dressed in regular clothes, with only a few in bathing suits. In the background are houses built on the dunes. (Author's archives.)

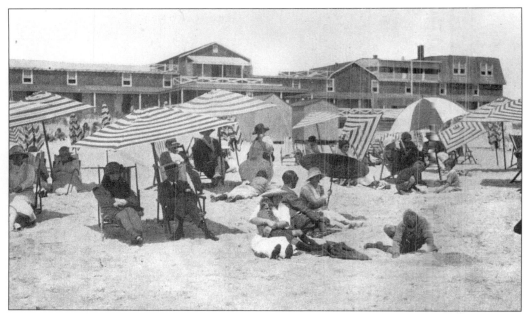

People crowd the beach in this mid-1920s picture. Most are dressed in clothing of the day and some sit under striped umbrellas while children play in the sand. In the background is Culver's Bathing Pavilion, built at the end of Ocean Avenue by Austin H Culver in 1901. (Dan Powers.)

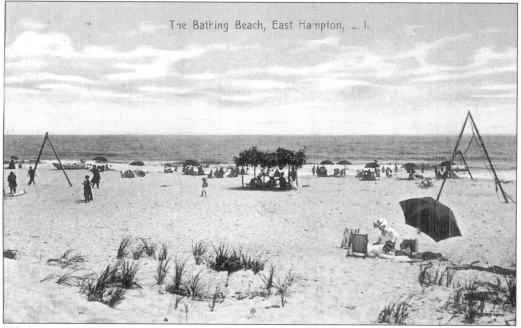

The Bathing Beach, East Hampton, L. I.

While one group of beach goers relies on a brush-covered shade mounted on four poles for protection from the sun, others have erected umbrellas. Most of the people in this July 1909 image are dressed in regular clothing; only a few wear the bathing suits of the day. (Author's archives.)

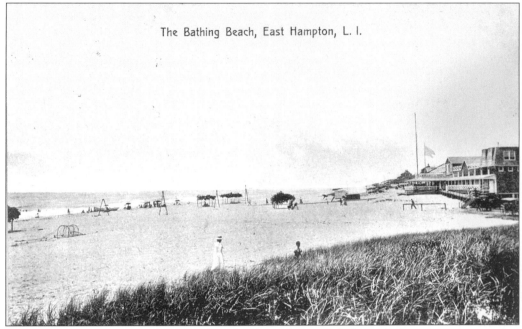

The Bathing Beach, East Hampton, L. I.

Looking west, the beach is dotted with umbrellas and open-sided sun shade canopies covered in this image dating to 1909. The pavilion, with its wide veranda overlooking the ocean, is at the far right next to a wooden walkway leading to the parking area. (Author's archives.)

Shown is the pavilion at Main Beach at the end of Ocean Avenue today. Constructed in 1901, it suffered heavy damage from several hurricanes. In 1925, Culver sold it to a group of summer residents who also bought the adjacent Sea Spray Inn. (Author's archives.)

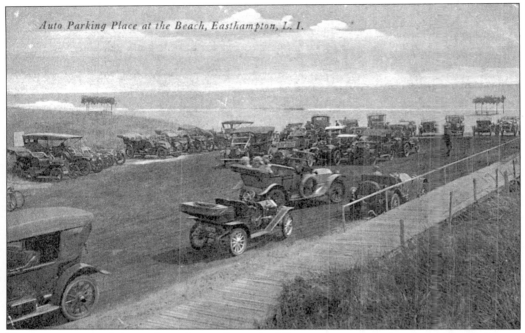

Auto Parking Place at the Beach, Easthampton, L. I.

Vintage cars crowd the parking lot at the end of Ocean Avenue in this image dated August 1920. Earlier, a stagecoach made regular runs to the beach from the center of the village for the convenience of bathers. A wooden walkway on the right leads to Culver's Pavilion and the beach. (Author's archives.)

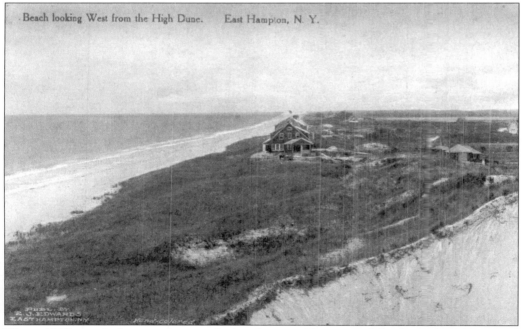

Beach looking West from the High Dune. East Hampton, N. Y.

This *c.* 1920 view looks west, showing the beach, several houses, and the dunes that are covered with beach grass to prevent erosion. Hook Pond is in the background. (Author's archives.)

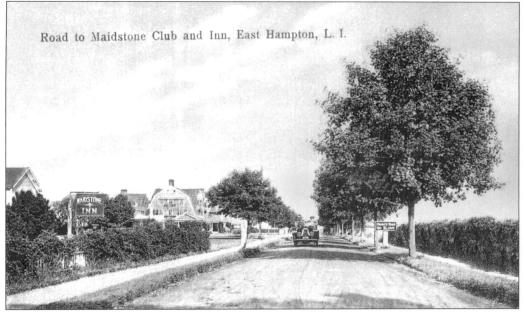

Road to Maidstone Club and Inn, East Hampton, L. I.

One block long, Maidstone Lane leads from James Lane to the Maidstone Inn and the Maidstone Club. A sign on the left of the road reads, "Maidstone Inn." Another on the left states that it is a private road and warns motorists to go slow. (Harvey Ginsberg postcard collection.)

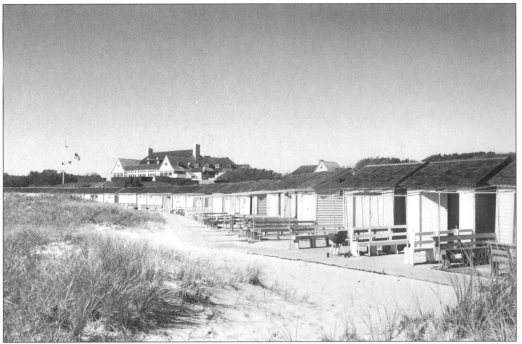

Facing the ocean behind a low, grass-covered dune, the Maidstone Club frame cabanas connected by a wooden boardwalk are all painted different colors. In the summer, awnings are stretched on the supports in front of each cabana. As early as 1939, there were 104 cabanas, 75 ladies' dressing rooms, and 60 men's dressing rooms. (Author's archives.)

116

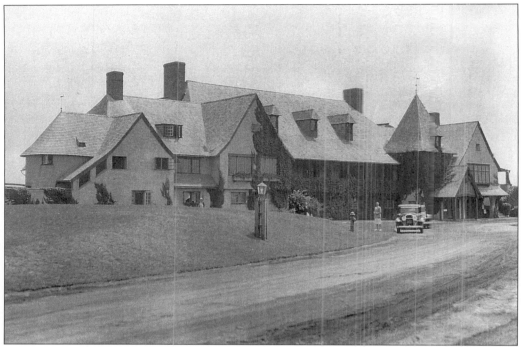

Founded in 1891, the Maidstone Club is the gathering place for the summer colony. The front of the third clubhouse in this 1920s photograph overlooks the golf course and ocean. The first two clubhouses were on Maidstone Lane overlooking Hook Pond. The first, built in 1892, burned in 1901; the second burned in 1922. The five-acre tennis complex survives on Maidstone Lane. (John W. Rae Jr. collection.)

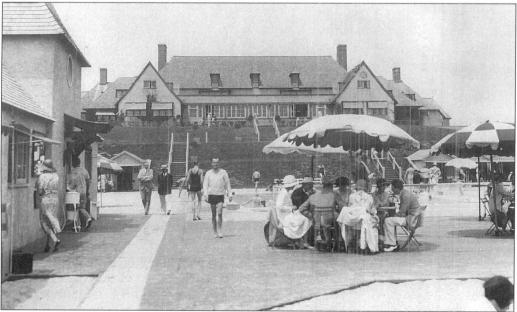

The club's poolside patio, just below a broad grass terrace, where lunch is served, overlooks the ocean. The pool and cabanas, some of which have their own sun-yard and shower, opened July 28, 1928. (John W. Rae Jr. collection.)

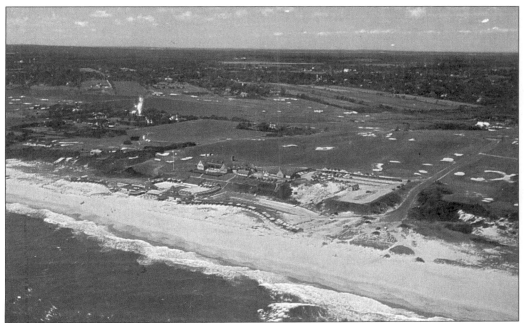

This aerial view of the Maidstone Club shows its two golf courses, a pool, cabanas facing the beach, and parking lots off Old Beach Lane. In the background is Hook Pond. (Dave Edwards photograph.)

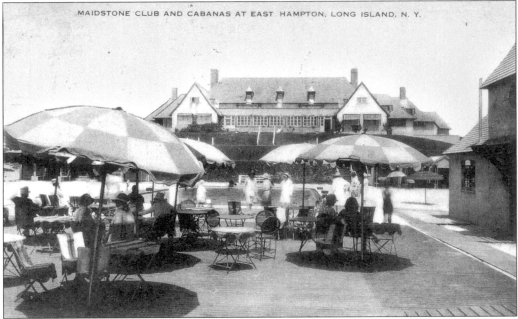

This more recent view of the pool patio with its colorful tables was taken in September 1941. In 1914, Dr. Everett Herrick, a club founder and its president, left a conditional legacy of $7,500 to the club. It banned liquor and stipulated all tennis matches be decided by three sets out of five, not two out of three. The ban was quickly lifted. (Author's archives.)

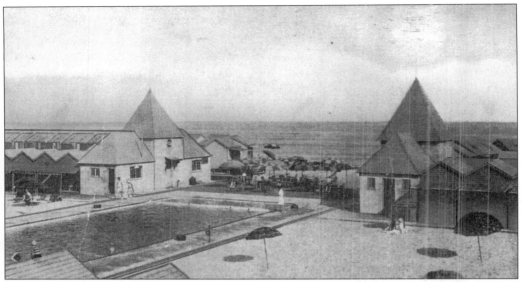

Below the clubhouse, the pool, its cabanas, and patio overlook the beach. Additional cabanas were constructed after the opening of the pool to satisfy some members who threatened to leave and build their own clubhouse. (John W. Rae Jr. collection.)

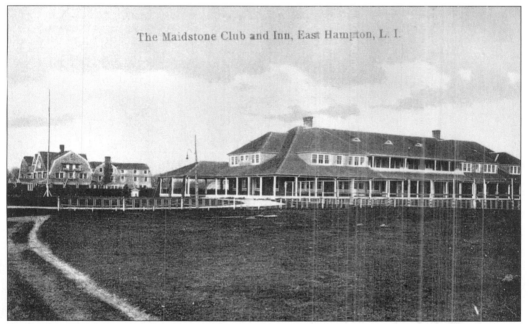

The Maidstone Club and Inn, East Hampton, L. I.

Built after fire destroyed the first clubhouse, the second Maidstone Clubhouse at the end of Maidstone Lane had wide verandas. In the background is the Maidstone Inn, East Hampton's first large hotel, built in 1901 to accommodate the growing influx of summer visitors. (Harvey Ginsberg postcard collection.)

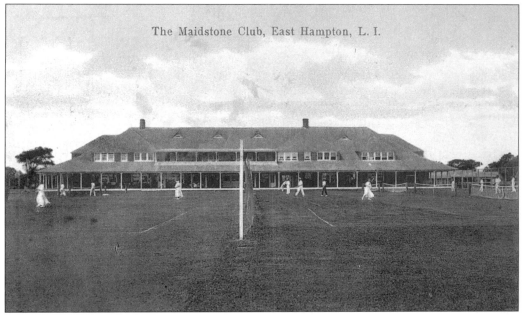

The Maidstone Club, East Hampton, L. I.

Men and women play on the all-grass tennis courts at the Maidstone Club in 1910. The courts are part of the five acres of club grounds devoted to tennis courts, both grass and clay. The clubhouse in the background with its wide veranda is the second built after fire destroyed the first. (Author's archives.)

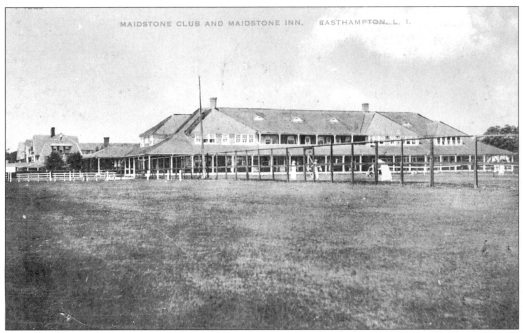

MAIDSTONE CLUB AND MAIDSTONE INN. EASTHAMPTON, L. I.

Shown are women playing tennis on the Maidstone Club courts in 1919, when the wire fence surrounding the courts was supported by wooden posts. The club grew from the East Hampton Lawn Tennis Club that was formed in 1869. (Author's archives.)

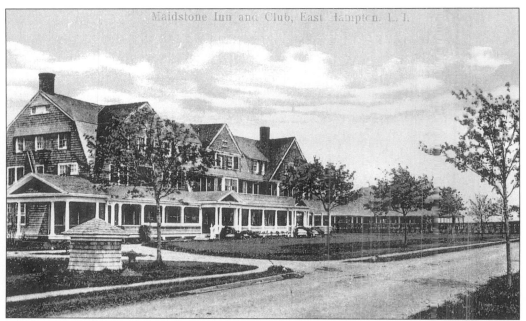

East Hampton's first large hotel, the Maidstone Inn, a three-story, shingle-style structure. was built on Maidstone Lane adjacent to the Maidstone Club in 1901 Designed by I.W. Green Jr., it was a rambling structure with a gambrel roof and 15-foot wide verandas. It burned in January 1935. (Harvey Ginsberg postcard collection.)

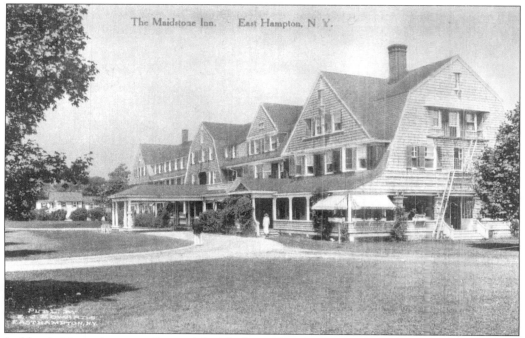

Ladders led from the upper floors of the Maidstone Inn for use in a fire. This view, from the east, shows the curving driveway entrance, the wide veranda (covered partially with awnings), and a portico shielding the main entrance. (Harvey Ginsberg postcard collection.)

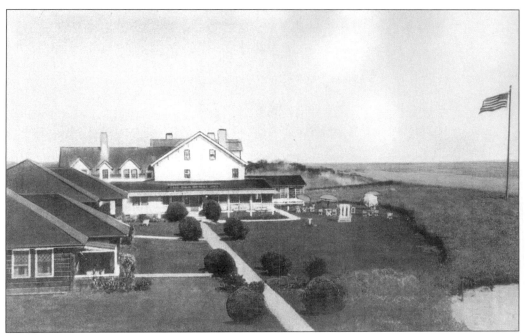

Facing the Atlantic Ocean from atop a dune east of Ocean Avenue, the Sea Spray Inn, originally built as a home on Main Street, was moved to the dunes in 1902. Opened in 1888 as Abraham Candy's boardinghouse, it was a popular vacation spot patronized by artists. Fire of "undetermined origin" leveled the inn February 18, 1978, but its cottages and flagpole survive. (Harvey Ginsberg postcard collection.)

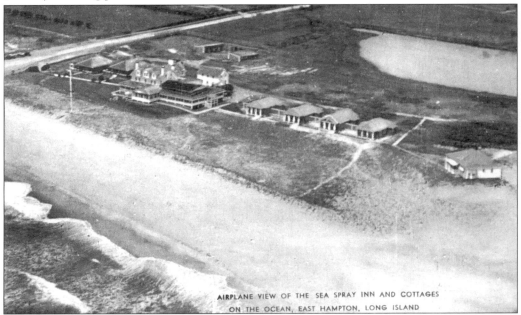

The Sea Spray Inn with its wide porches, cottages, a flagpole, and parking lot on Ocean Avenue are shown in this 1943 aerial picture. The parking lot was shared jointly by the inn and Culver's Bathing Pavilion. When the inn was moved from Main Street, it was enlarged, and the cottages were added. (Author's archives.)

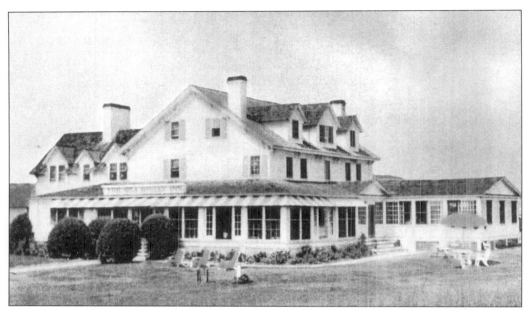

The core section of the inn was moved from Main Street. The job took several weeks with the building mounted on timbers and wheels, drawn by teams of horses. The restaurant and bar, facing the ocean, was a popular dining spot for generations. (Harvey Ginsberg postcard collection.)

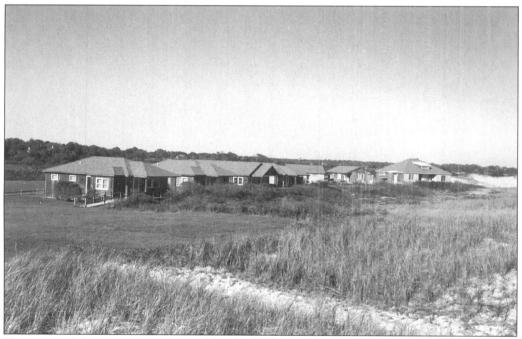

Shown are the cottages, now owned by the Village of East Hampton, as they appear today. There is a long waiting list to rent them. The steel flag pole, its flag once visible for miles, is atop the dune to the right, just out of view.. (Author's archives.)

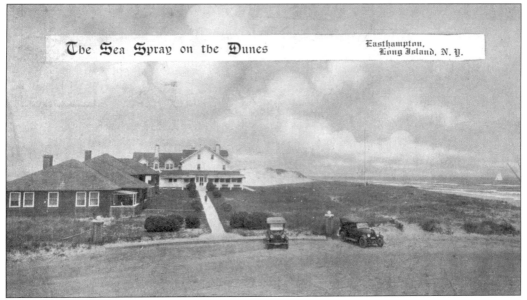

The Sea Spray on the Dunes Easthampton, Long Island, N. Y.

Shown are the cottages, the ocean, and the Sea Spray Inn parking lot with two vintage cars. After Terbell's ownership, the inn was sold again in 1924 to a group of summer residents who also bought the bathing pavilion across Ocean Avenue. (Author's archives.)

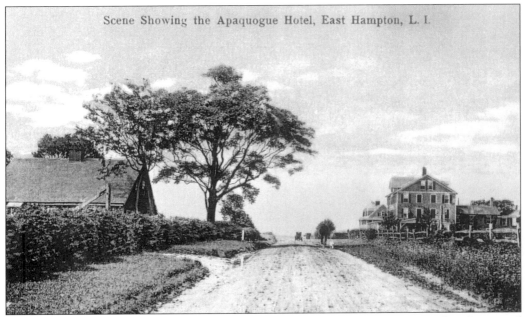

Scene Showing the Apaquogue Hotel, East Hampton, L. I.

Pictured is the Apaquogue Hotel, built as a boardinghouse by Abraham D. Candy, who owned a 107-acre farm on Apaquogue Road. It has a long history of sales. Candy sold it to Mrs. E.A. LaForest of New York in 1882. Two years later, after it burned, she rebuilt it. In 1912, it was sold to Mrs. A.A. Cater and in 1919, to Julian S. Myrick, each of whom intended to convert it to a summer residence. (Harvey Ginsberg postcard collection.)

Seven
GARDINER'S ISLAND

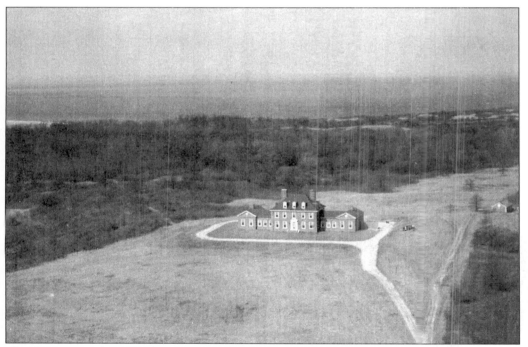

The Georgian-style manor house on Gardiner's Island sits in a large clearing in the center of the 3,300-acre island, part of the town of East Hampton. Since 1639, it is the third manor house built on the crescent-shaped island, two of which were built on the same site. The first burned in 1774 and the second in 1947. (David Edwards photograph.)

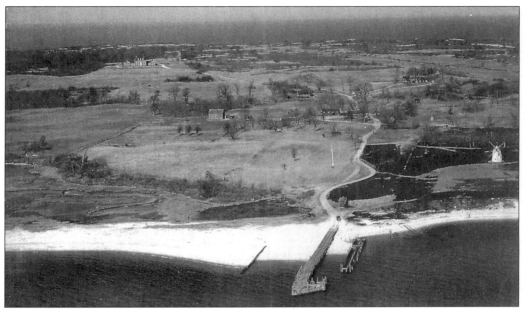

This aerial view shows the dock on Gardiner's Island, the road leading to the manor house, the windmill, numerous barns, Bostwick Wood, and Cherry Harbor. The pirate Captain Kidd buried a quantity of gold, silver, and precious stones in a swamp on the island in 1699. (David Edwards photograph.)

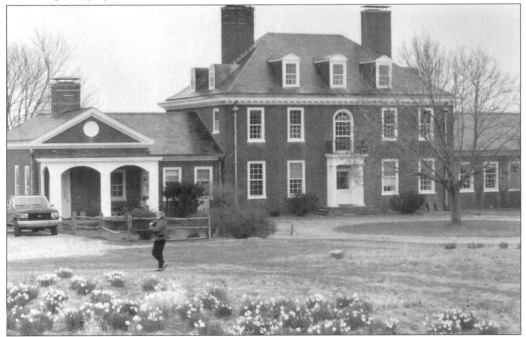

Miss Sarah Diodati Gardiner, a descendant on both her paternal and maternal side from the first Lion Gardiner, built the third manor house on the island. A Georgian-style red brick residence, larger and finer than the second, it commands a hill with a view of the island and surrounding waters. The 15th proprietor of the island, she divided her time between New York and East Hampton, where the Gardiner's owned much property. (C.E. King Jr. archives.)

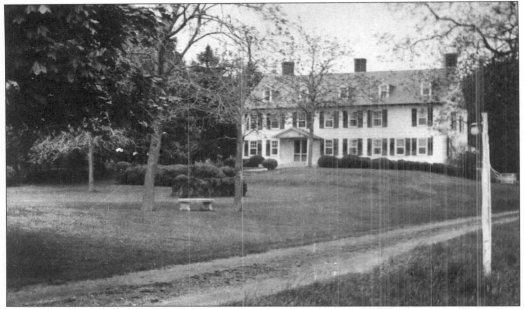

Built in 1774, the second manor house, a three-story frame structure painted white, was built on the site of the first manor house that had been built in 1639. Like the first, it was a three-story frame structure with three chimneys and a wide front porch. It burned down on January 24, 1947. Miss Sarah Diodati Gardiner, who bought the island to keep it in the family, placed a bronze marker on a boulder at the site in 1952. (C.E. King Jr. archives.)

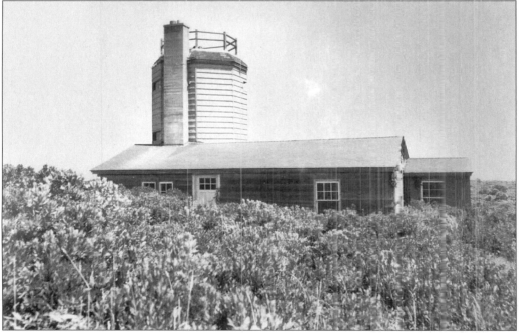

Built atop a silo on the eastern plains bluff of Gardiner's Island, this WWII observation post commanded a view of the entrance to Long Island Sound. It was manned on an around-the-clock basis by the U.S. Coast Guard. The island is three miles off Long Island. (C.E. King Jr. archives.)

Shown is the dock at Gardiner's Island in 1930. From 1920 to 1945, Clarence H. Mackay, who had inherited silver mines, telephone services, and cable services worth $500 million, leased the island and manor house as a private hunting preserve. He paid the rate of $10,000 per year in addition to East Hampton taxes. The cost brought the tab for his hunting outings to $1,000 per day. (C.E. King Jr. archives.)

This building, once slave quarters, was used to house the 100 drovers whom Mackay employed during his hunts to drive the game into the open. Much of the game had been imported from abroad. In the 19th century, the island was self-sustaining, selling surplus goods to whaling ships. Butter and cheese were made, wool and flax spun, candles dipped. Apples were made into cider and cattle, sheep, blooded horses, and hogs were raised. (C.E. King Jr. archives.)